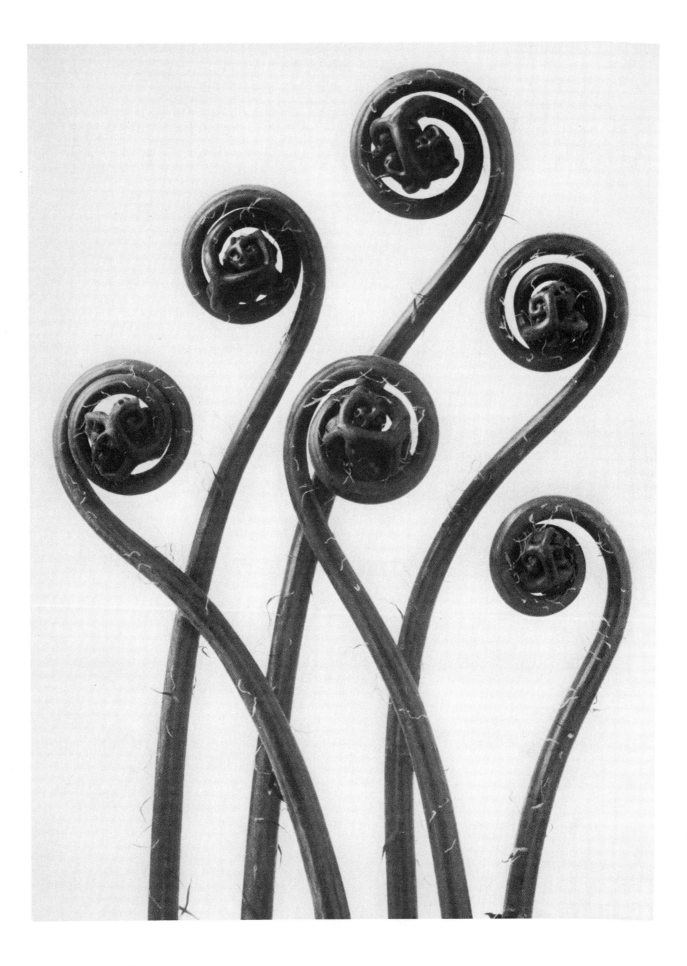

# ART FORMS IN THE PLANT WORLD

*120 Full-Page Photographs*

## Karl Blossfeldt

*With an Introduction by*
Karl Nierendorf

Dover Publications, Inc.
New York

# PUBLISHER'S NOTE

A sculptor and art teacher by profession, Karl Blossfeldt is best known today for his austerely beautiful photographs of plant forms. Originally intended strictly as models for his sculpturing and as teaching aids, Blossfeldt's exquisite photographs first came to the public's attention in 1928 when a selection appeared in the volume *Urformen der Kunst (Archetypes of Art)*, the original German version of the present edition. Almost immediately the book created a sensation in the photographic world, and Blossfeldt was rushed to the fore in the German post-World War I movement to abandon the soft-focus, impressionistic style in favor of a direct-lighting, sharp-focus approach—part of the "New Objectivity" wave in German art in general. In 1932, the year he died at the age of 67, he published a second book of plant photographs. Even now Blossfeldt's photographs continue to be prominently exhibited throughout the world and invariably receive acclaim for their majestic beauty.

Blossfeldt composed his images with deliberation, leaving nothing to chance. And yet, despite his black-and-white, straightforward, frontal approach, his photographs offer more than a cold, detached study of the parts of plants. They reflect a poetic interpretation of the relationship between nature and art. In the infinite variety of forms in the plant world, Blossfeldt revealed shapes and structures that resemble the forms of man's architectural and other artistic styles throughout history, suggesting that art mirrors nature's designs. And nature, because it gives its creations specific essential and efficient forms to assure their continued existence, can be seen as creating its own art, a functional art based on survival. Surely Blossfeldt believed that in his pictures he was demonstrating this fundamental interdependence of man's world and the plant world, and showing that art is not exclusive to either.

However you approach these 120 plates of plant photographs, whether as a student of one of photography's masters and of his techniques or as a natural historian investigating the intricacies of the plant world, as an artist or a philosopher, you will undoubtedly find inspiration and enjoyment in the sheer beauty of Blossfeldt's work. From ordinary bits of stem, leaf, frond, flower and seed pod he has achieved striking designs that reveal the glory of the art of man and nature.

In the captions of the present edition, many of the plant names have been corrected or brought up to date; the English names included are now the most common and the most familiar to American readers. The amounts of magnification or reduction given correspond to the images in the present edition.

---

This Dover edition, first published in 1985, is an unabridged republication of the work first published by E. Weyhe, New York, in 1929 under the title *Art Forms in Nature: Examples from the Plant World Photographed Direct from Nature*. (The original German edition was first published by Verlag Ernst Wasmuth A. G., Berlin, in 1928 under the title *Urformen der Kunst: Photographische Pflanzenbilder*.) The descriptions of the plates, which appeared in the front matter of the original edition, have been corrected slightly and appear as captions to the plates in the present edition. The 1929 translation of Nierendorf's introduction has been amended on the basis of the original German text. The new Publisher's Note was written specially for the Dover edition.

Manufactured in the United States of America
Dover Publications, Inc., 31 East 2nd Street, Mineola, N.Y. 11501

**Library of Congress Cataloging in Publication Data**

Blossfeldt, Karl, 1865–1932
  Art forms in the plant world.

  Reprint. Originally published: Art forms in nature. New York : E. Weyhe, 1929.
  1. Decoration and ornament—Plant forms. I. Title.
NK1560.B52   1985      745.4         85-12897
ISBN 0-486-24990-5 (pbk.)

# INTRODUCTION

## by Karl Nierendorf

Art and nature, the two great manifestations in the world around us, are so intimately related that it is impossible to think of one without the other, and so we can never compress them into a single formula. Infinitely multifarious as the realm of the crystalline, animal and vegetable forms which grow and perish with us may be, they are governed by a rigid and eternal law emanating from beyond this earth, and obey the profoundly mysterious fiat of creation that called them into existence. For thousands of years every form in nature has been a constant repetition of the same process, subject only to alterations due to climatic changes or the varying character of the soil, which do not interfere with its basic shape. The fern and the horsetail already had their present form in inconceivably remote ages. Their size alone has undergone alterations through the development of the atmosphere of this planet.

It is the result of the creative act that distinguishes works of art from those of nature, namely, the modeling of an original form, newly produced, and not the imitated or repeated form. Art has its immediate origin in the latest powerful incentive existing at the time, of which it is the most visible expression. In the same way that a blade of grass in its timelessness appears monumental and worthy of veneration, as a symbol of everlasting primeval laws governing all life, so a work of art has an overwhelmingly moving effect through its very uniqueness as the most concentrated manifestation, as an arc of light joining the two poles of the past and future. From the Assyrian temple to the stadium of the present day, from the Buddha absorbed in meditation to the Thinker of Rodin, from the Chinese color wood engraving to the modern gravure reproduction, everything created by man records the spirit of his epoch with such distinctiveness that it is easy to deduce from it the actual date of its creation. In the artistic production of every generation, its relation to nature, as well as to God and the science of mathematics, is documented. And the more securely the actual present is enshrined in a work, the greater will be its value for eternity.

If man in the space of thousands of years produced the same style of architecture and the same forms of art without variation, his creations would amount to no more than the structures erected by bees and termites: mere products of nature on the same level as the complicated nests of many birds, the web of a spider and the shell of a snail. But what exalts man above the other creatures is his capability of transformation by aid of his own spiritual force, which gave the Catholic of the Middle Ages and his entire world a totally different structure from that, for instance, of the Greek of classical times. Just as nature, in its endless monotony of origin and decay, is the embodiment of a profoundly sublime secret, so art is an equally incomprehensible second creation, emanating organically from the human heart and the human brain: a creation which from the very beginning of time and throughout the ages has had its origin in the yearning for perpetuity, for eternity, and in the desire to retain the spiritual face of its generation—doomed to be engulfed in the whirlpool of time—in stone, bronze, wood and painted images that are independent of birth and death.

This may be said of mankind of the present day, as well as of any other period. We are witnesses of the fact that modern youth is rising up in revolt against merciless materialism and intellectualism, dictated by the rapid progress of our time, and is returning to nature with elemental vigor. Sport, a powerful manifestation common to every country on earth, here provides the necessary compensation. A new type of man is appearing—a free being, rejoicing in healthy exercise, intimately acquainted with the elements air and water, tanned by the sun and resolved to open out for himself a new and brighter world. He recognizes the cheering and health-giving powers of light, air and sunshine; he seeks the penetration of his body by the rays of the sun, the illumination of his whole being and the transformation of all the various phases of life; in other words, he aims at active and immediate union with nature. Simultaneously a new form of architecture is breaking through the dark stone caverns, opening out wide vistas by means of lightweight walls of glass and actually joining the house organically with a garden whose fantastic riches have only been made possible by the development of new species of flowers and the thoughtful patterns of their planting. And, beyond the garden, the motorcar is creating intimate contact between town and country.

With the aid of quick motion and slow motion we can experience in films the expansion and contraction, the breathing and the growth of plants. The microscope reveals systems of worlds in a single drop of water, and the instruments of the observatory reveal the infinite depths of the universe. It is modern technology that

brings us into closer touch with nature than was ever possible before and, with the aid of its new tools, offers glimpses into worlds which hitherto had been hidden from our senses. And it is technology also that provides us with new means of artistic creation. If the expression, "The battles of the spirit are fought out on canvas," was justified in the nineteenth century, when the highest art form was painting, today the fight is waged with iron, concrete, steel and with waves of light and ether. Our architecture, engineering, motorcars and airplanes, as well as the film, the radio and photography, contain fantastic possibilities of a high artistic order, and a thousand signs indicate that the triumph of technology, so often deplored, is not the victory of matter but of the creative spirit, which is only manifesting itself in new forms.

Thus, it is not by chance that a work is now published which, with the aid of the photographic camera, by giving enlargements of parts of plants, reveals a relationship between art and nature never heretofore represented with such startling immediacy. Professor Blossfeldt, sculptor and teacher at the Combined State Schools of Fine and Applied Art in Berlin, in hundreds of photographs of plants that have not been retouched or artificially manipulated but solely enlarged in different degrees, has demonstrated the close connection between forms produced by man and those developed by nature.

The following selection comprises 120 plates from this rich material, and each reveals the unity of the creative will in nature and art, documented by the objective evidence of the photographic plate and, therefore, all the more convincing. And as it was a person of eminence who recognized this domain as being his own particular one to develop and consequently adopted it as the aim of his life, there was unfolded to the artist who approached nature with the eye of the camera a world comprising all forms of past styles, from dramatic tension to austere repose, and even to the expression of lyrical and profound inspiration. The fluttering delicacy of a Rococo ornament, as well as the heroic severity of a Renaissance candelabrum, the mystically entangled tendrils of the Gothic flamboyant style, noble shafts of columns, cupolas and towers of exotic architecture, gilded episcopal crosiers, wrought-iron railings, precious scepters, all these shapes and forms trace their original design to the plant world. Even the dance—a human body made art—finds its counterpart in a bud, with its touchingly innocent movement and its expression of the purest psychic effort, a dream apparition descending from the realm of visions into the flowery regions of our terrestrial world. The picture of this small germinating sprout (see Plate 96) bears witness with clear distinctness to the unity of the living and the created form. The dance, confined to the temporal occurrence of an event in nature, only becomes art by the repetition of motion as represented by the body according to fixed laws and in strictly defined rhythms. It is called upon to wrest from the flux of change that movement to which it cannot bestow permanence except by constant repetition. And while the bud of a plant again and again adopts that everlasting form which becomes for us the equivalent of an animated body, only to go on and continue its development, the dance arrests the psychic expression and thereby brings it close to the atmosphere of art, in which time stands still.

Manifold are the phases of life and manifold, also, are the transformations undergone by man. Elevating in its joyousness, far beyond the aesthetic sensation, is the recognition that the hidden creative forces, to whose fluctuations we as beings created by nature are subject, prevail everywhere with the same regularity, in the works produced by each generation as a simile of its existence, as well as in the most perishable and most delicate creations of nature.

If the reproductions in this book demonstrate distinctly for the first time the relations which become evident with increasing clearness, in the minute as well as in the great, they will contribute, on their part, to further the most important task that lies before us today, namely, to grasp the deeper meaning of our present time, which is striving for the recognition and realization of a new unity in all spheres of life, art and technology.

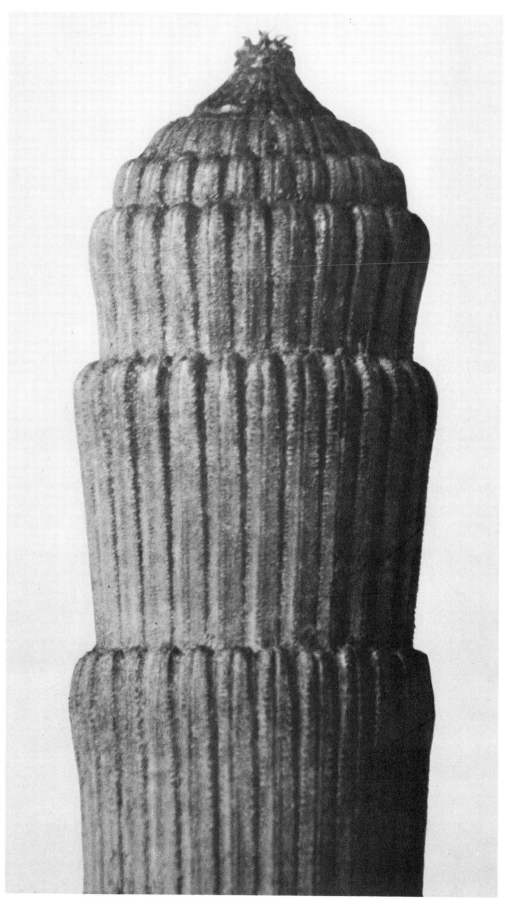

1. *Equisetum hiemale*. Winter Horsetail. Young shoot enlarged 22.5 times.

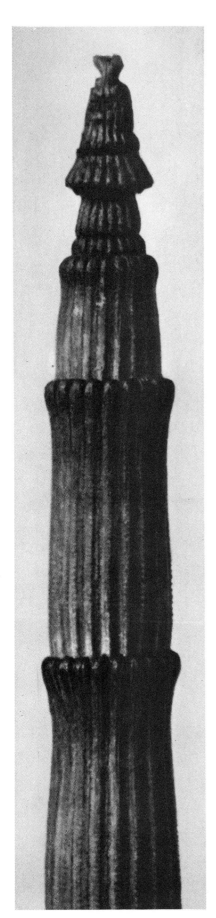 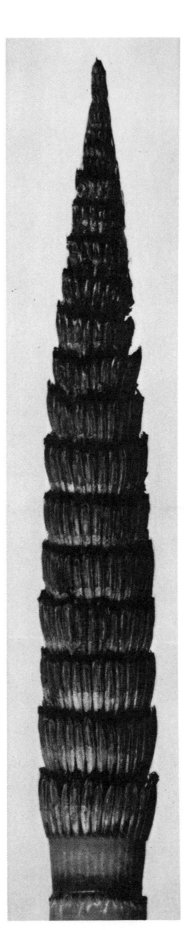 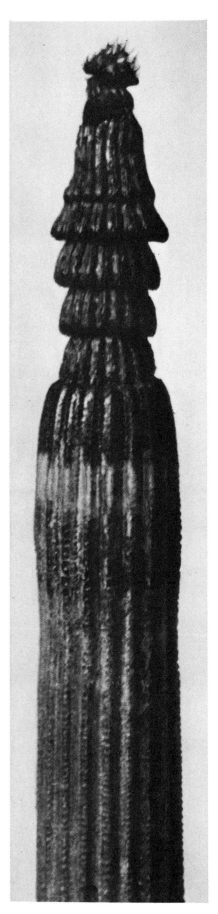

2. LEFT: *Equisetum hiemale.* Winter Horsetail. Shoot enlarged 10.8 times. CENTER: *Equisetum maximum.* Great or River Horsetail, Fox-tailed Asparagus. Shoot enlarged 3.6 times. RIGHT: *Equisetum hiemale.* Winter Horsetail. Shoot enlarged 16.2 times.

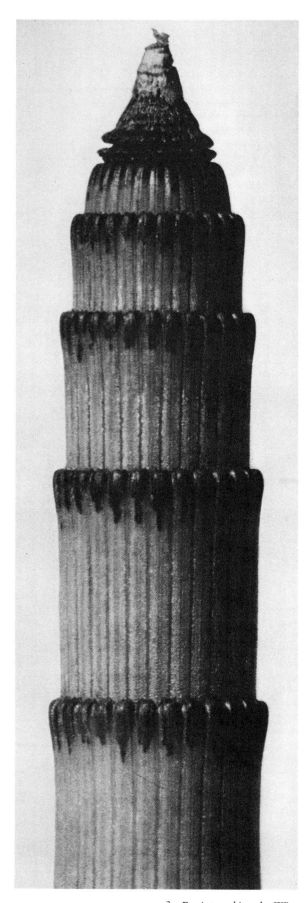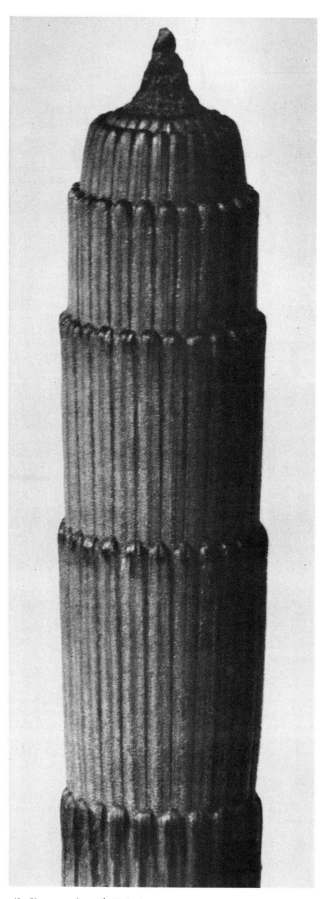

3. *Equisetum hiemale*. Winter Horsetail. Shoots enlarged 10.8 times.

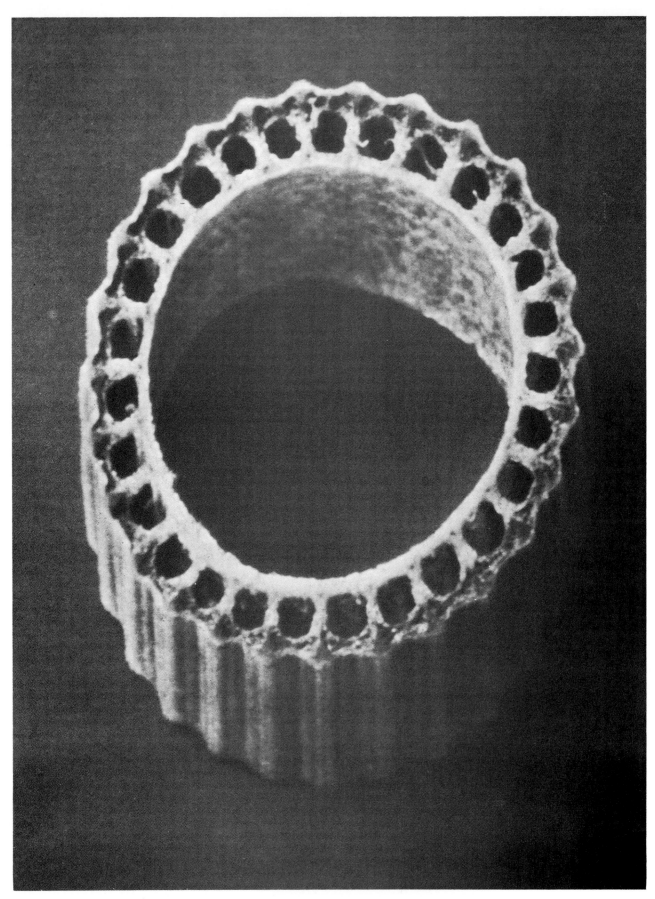

4. *Equisetum hiemale*. Winter Horsetail. Section of stem enlarged 27.0 times.

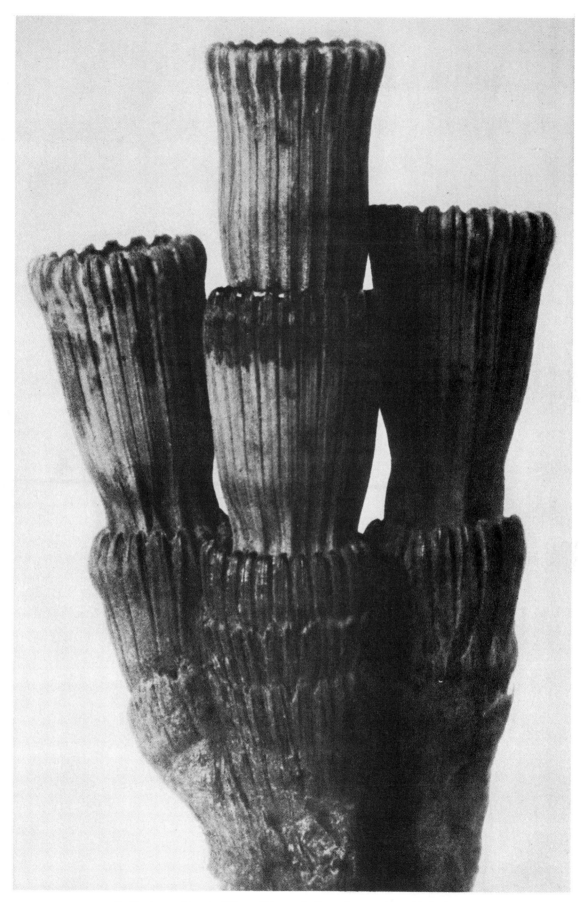

5. *Equisetum hiemale*. Winter Horsetail. Part of root enlarged 7.2 times.

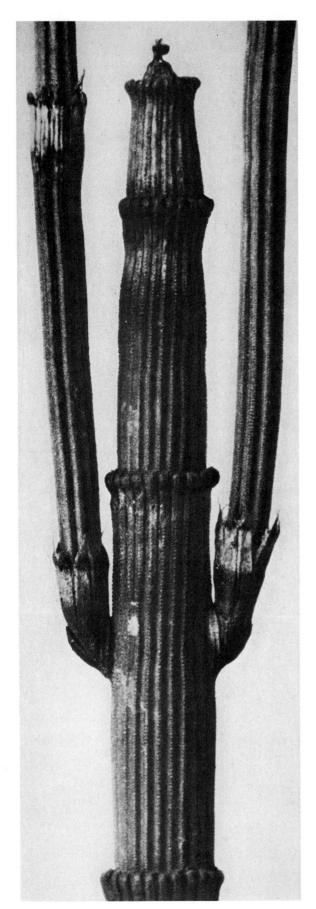 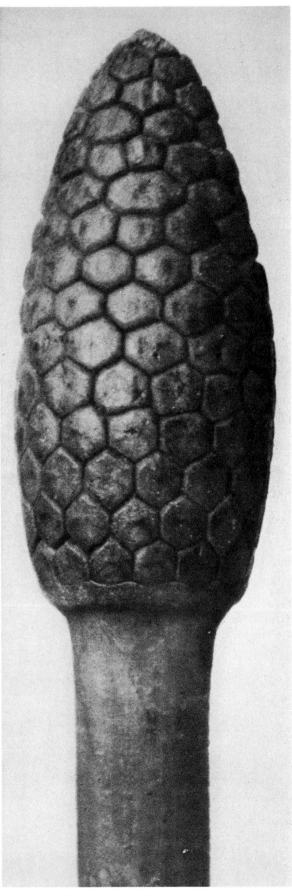

6. LEFT: *Equisetum hiemale.* Winter Horsetail. Shoot enlarged 7.2 times. RIGHT: *Equisetum arvense.* Bottlebrush, Field Horsetail. Fruit enlarged 10.8 times.

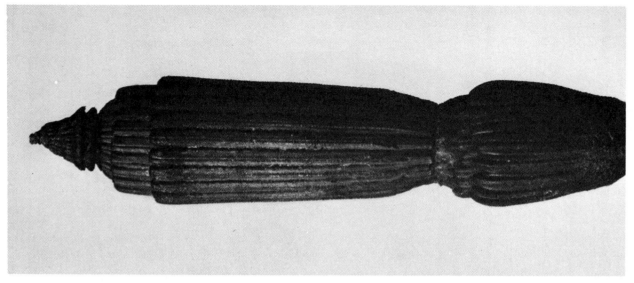

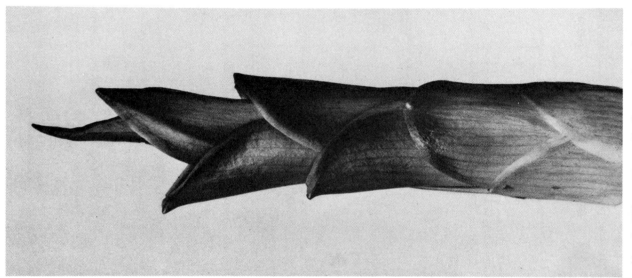

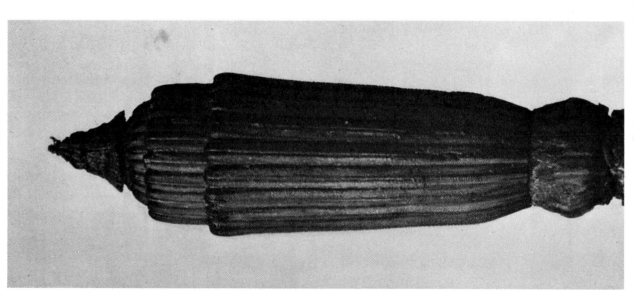

7. LEFT AND RIGHT: *Equisetum hiemale.* Winter Horsetail. Shoots enlarged 10.8 times. CENTER: *Hosta japonica.* Narrow-leaved Plantain-Lily, Funkia. Young shoot enlarged 3.6 times.

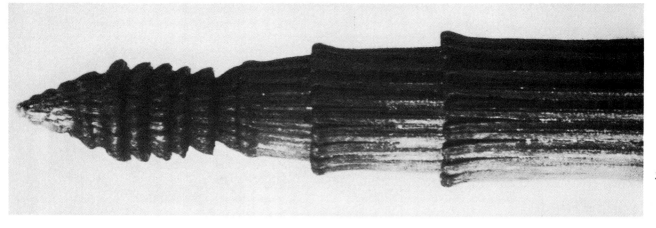

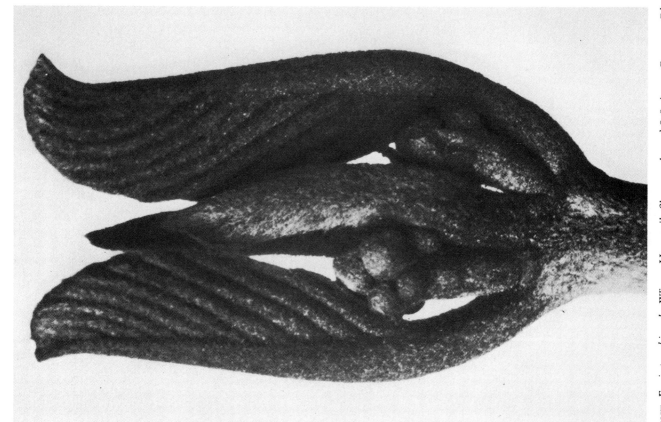

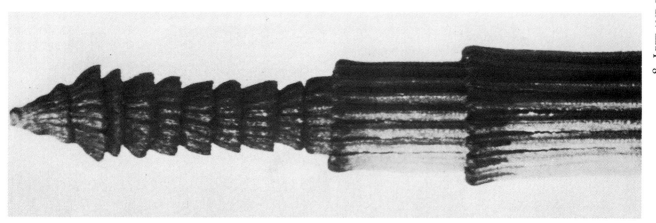

8. LEFT AND RIGHT: *Equisetum hiemale.* Winter Horsetail. Shoots enlarged 9.0 times. CENTER: *Rhamnus purshianus.* Californian Buckthorn. Young shoot enlarged 22.5 times.

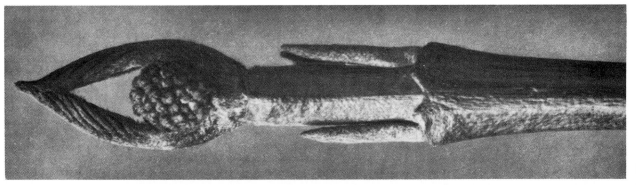

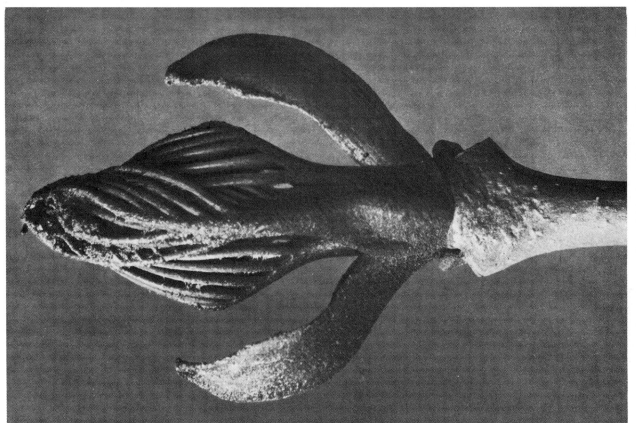

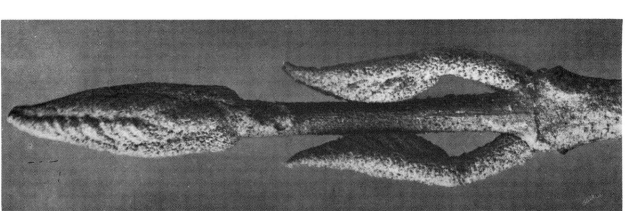

9. LEFT: *Callicarpa dichotoma*. Beautyberry. Shoot enlarged 6.3 times. CENTER: *Fraxinus ornus*. Flowering Ash. Shoot enlarged 5.4 times. RIGHT: *Cornus pubescens*. Dogwood. Shoot enlarged 7.2 times.

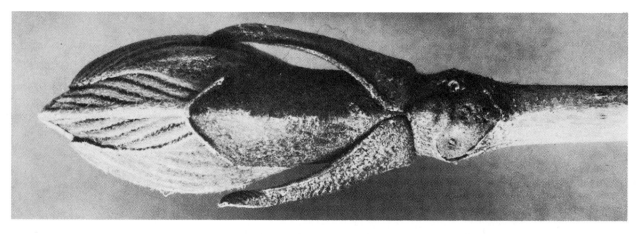

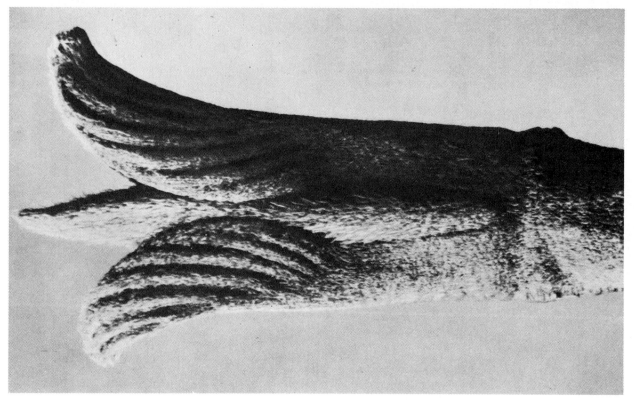

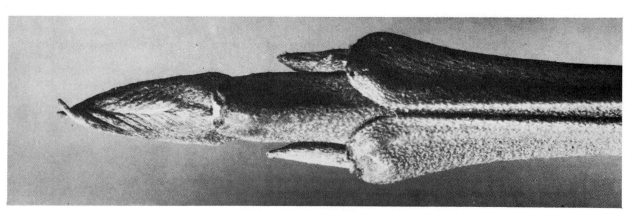

10. LEFT: *Cornus brachypoda*. Dogwood. Shoot enlarged 10.8 times. CENTER: *Cornus pubescens*. Dogwood. Leaf bud enlarged 13.5 times. RIGHT: *Viburnum*. Guelder-Rose, Snowball-tree. Leaf bud enlarged 7.2 times.

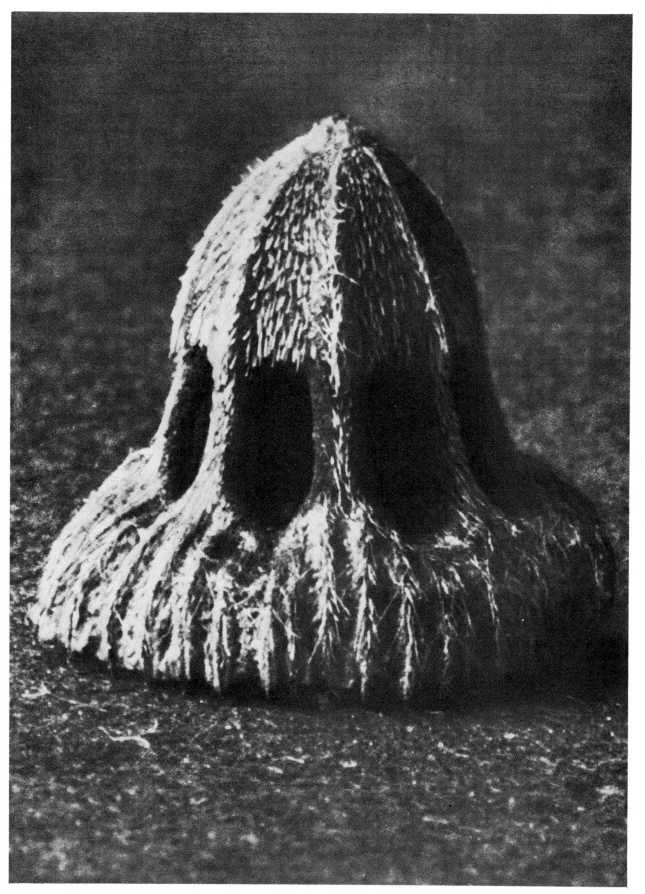

11. *Callistemma brachiatum*. Scabious. Seed enlarged 27.0 times.

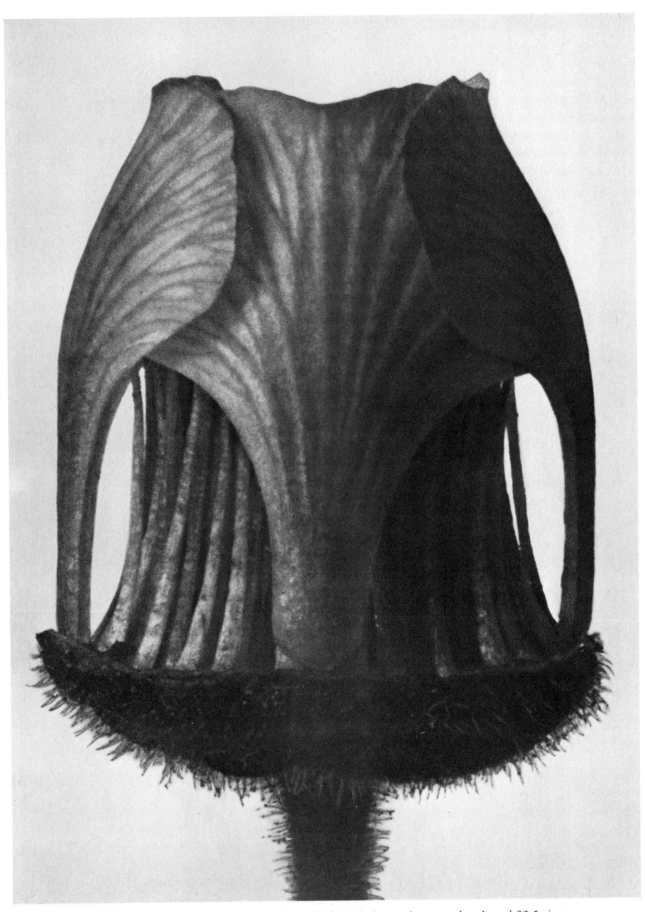

12. *Geum rivale*. Purple or Water Avens. Flower bud, with the sepals removed, enlarged 22.5 times.

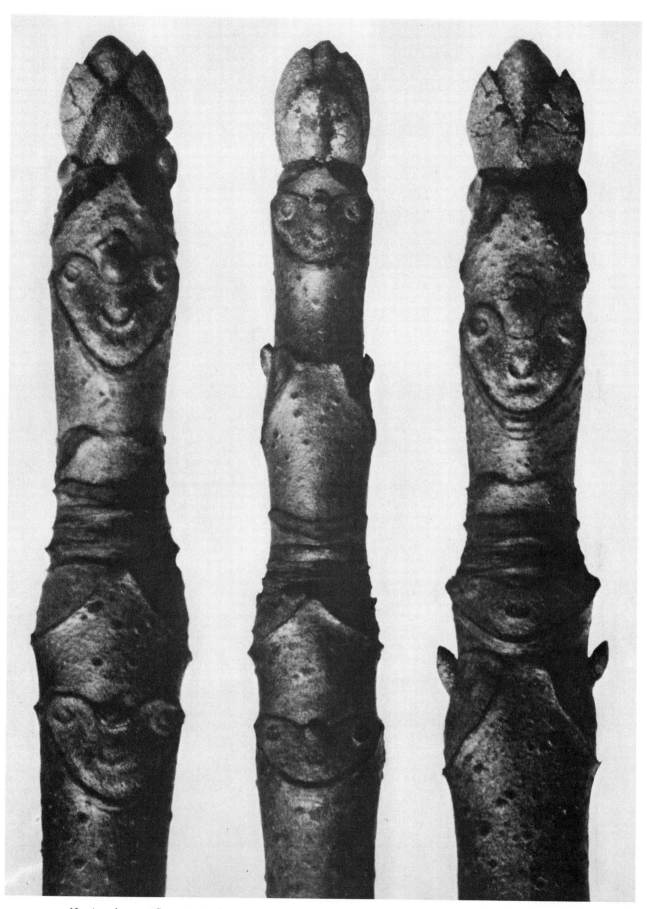

13. *Aesculus parviflora*. Small-flowered American Horse-Chestnut. Young shoots enlarged 10.8 times.

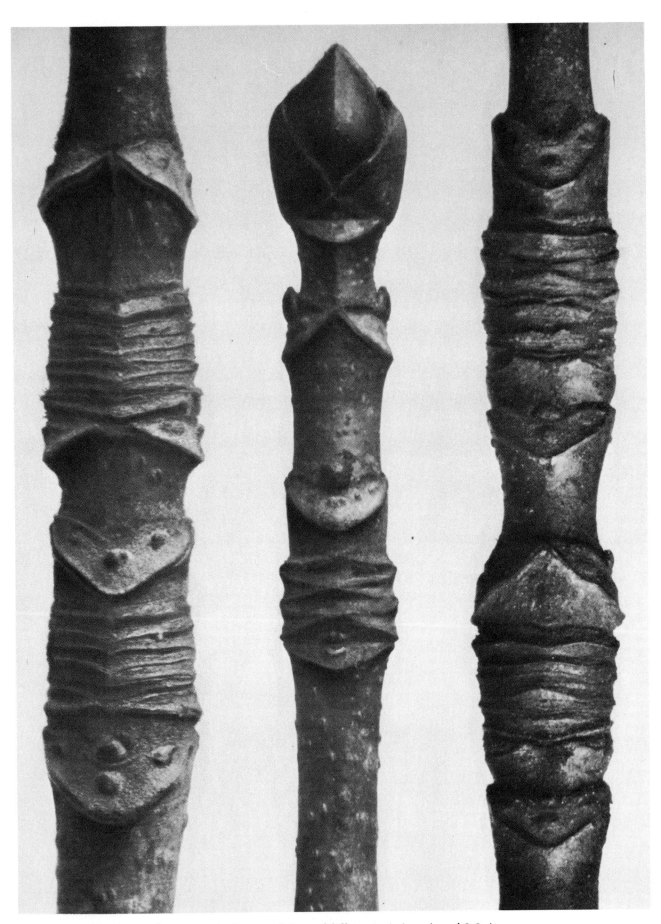

14. *Acer*. Maple. Stems and shoot of different varieties enlarged 9.0 times.

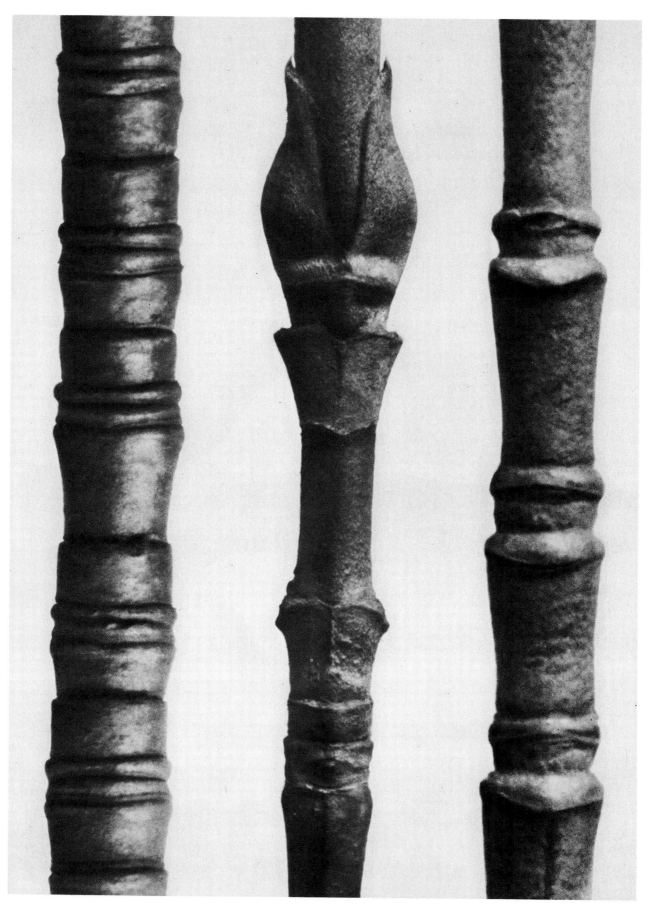

15. LEFT: *Cornus Nuttallii.* Nuttall's Dogwood. Branch enlarged 10.8 times. CENTER: *Cornus Nuttallii.* Nuttall's Dogwood. Branch enlarged 7.2 times. RIGHT: *Cornus florida.* Boxwood of N. America, Flowering Dogwood. Branch enlarged 22.5 times.

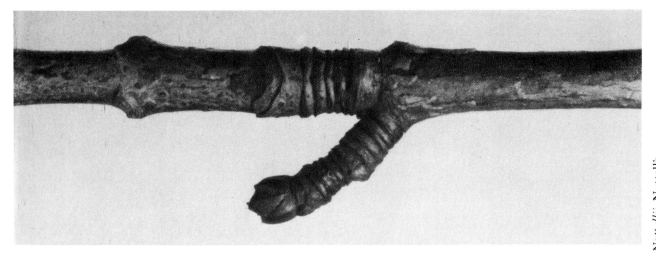

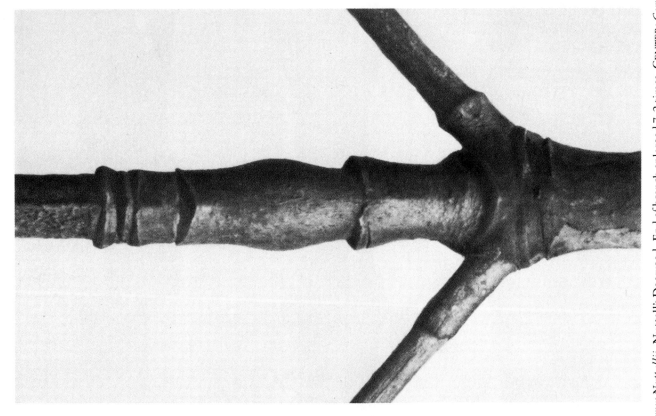

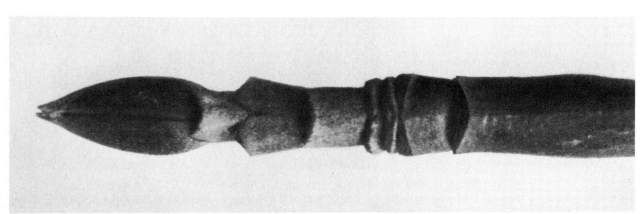

16. LEFT: *Cornus Nuttallii*. Nuttall's Dogwood. End of branch enlarged 7.2 times. CENTER: *Cornus Nuttallii*. Nuttall's Dogwood. Branch enlarged 7.2 times. RIGHT: *Acer*. Maple. Stem enlarged 7.2 times.

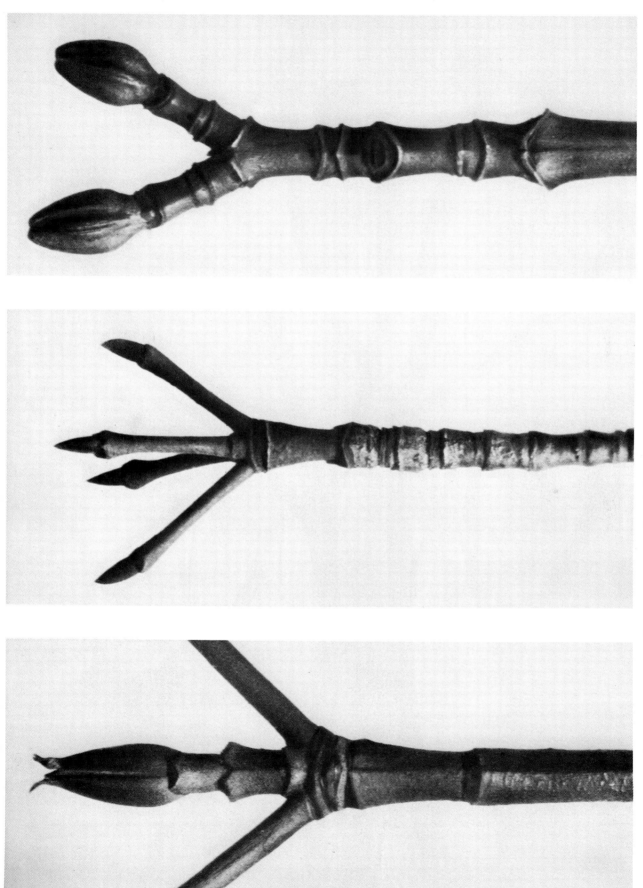

17. LEFT: *Cornus Nuttallii*. Nuttall's Dogwood. End of branch enlarged 5.4 times. CENTER: *Cornus florida*. Boxwood of N. America, Flowering Dogwood. End of branch enlarged 5.4 times. RIGHT: *Acer pensylvanicum*. Pennsylvanian Striped Maple. End of branch enlarged 5.4 times.

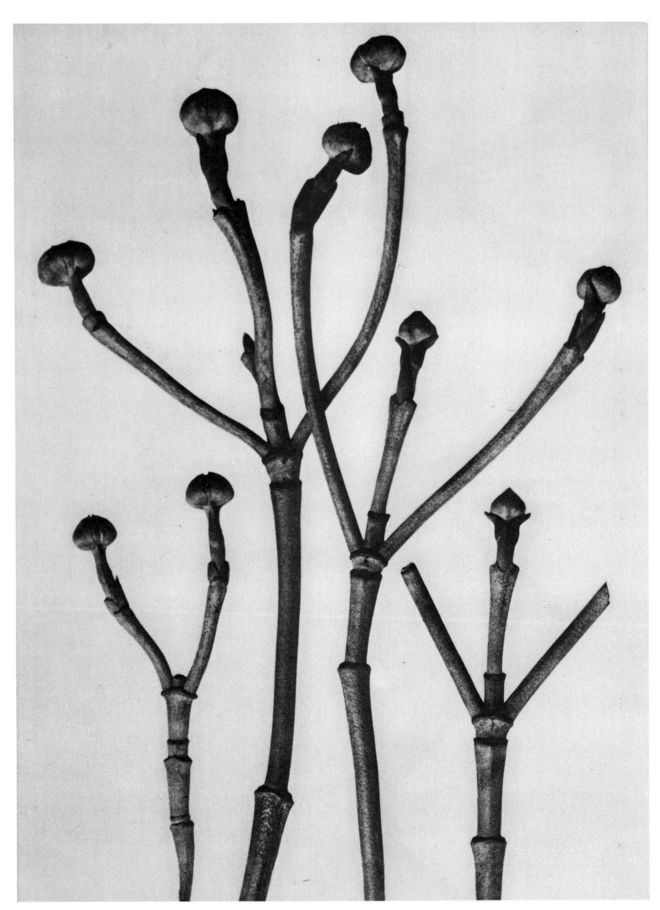

18. *Cornus florida*. Boxwood of N. America, Flowering Dogwood. Shoots enlarged 2.7 times.

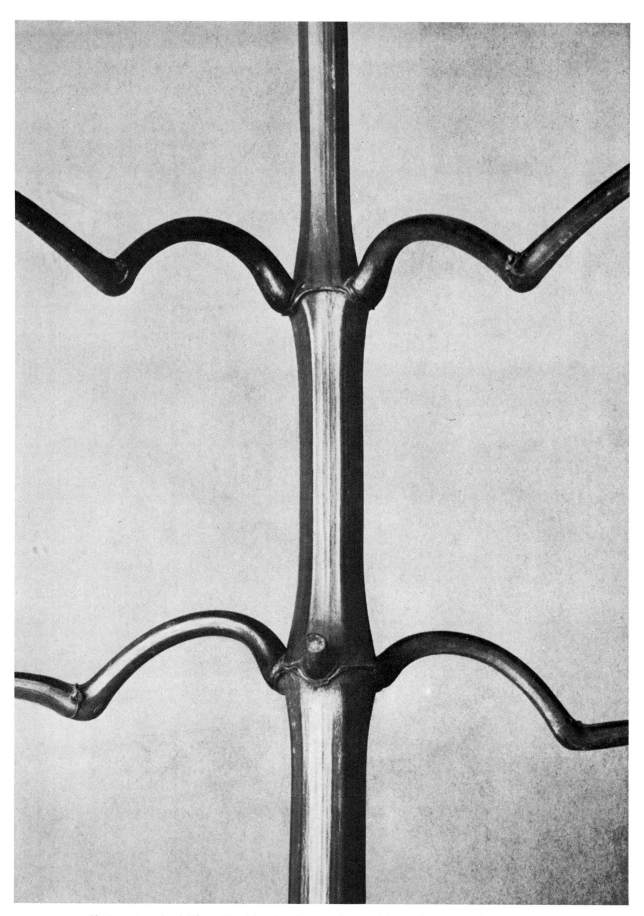

19. *Impatiens glandulifera*. Gland-bearing Balsam. Stem, with ramifications, reduced 0.1 time.

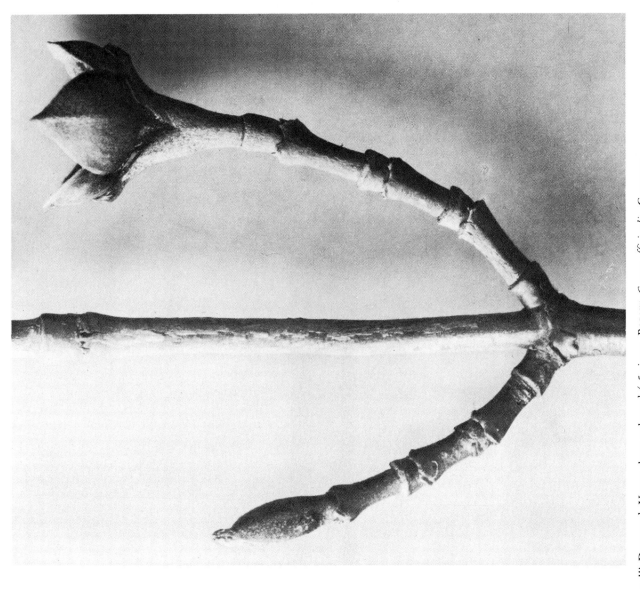

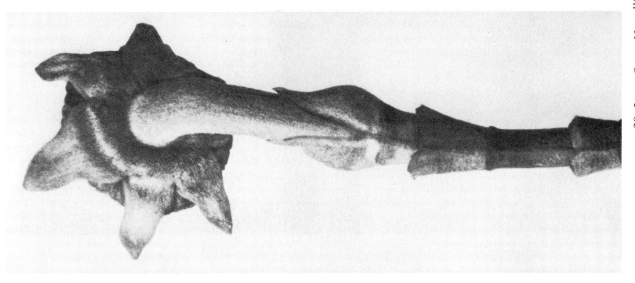

20. LEFT: *Cornus Nuttallii*. Nuttall's Dogwood. Young shoot enlarged 4.5 times. RIGHT: *Cornus officinalis*. Common Dogwood. Ramifications enlarged 7.2 times.

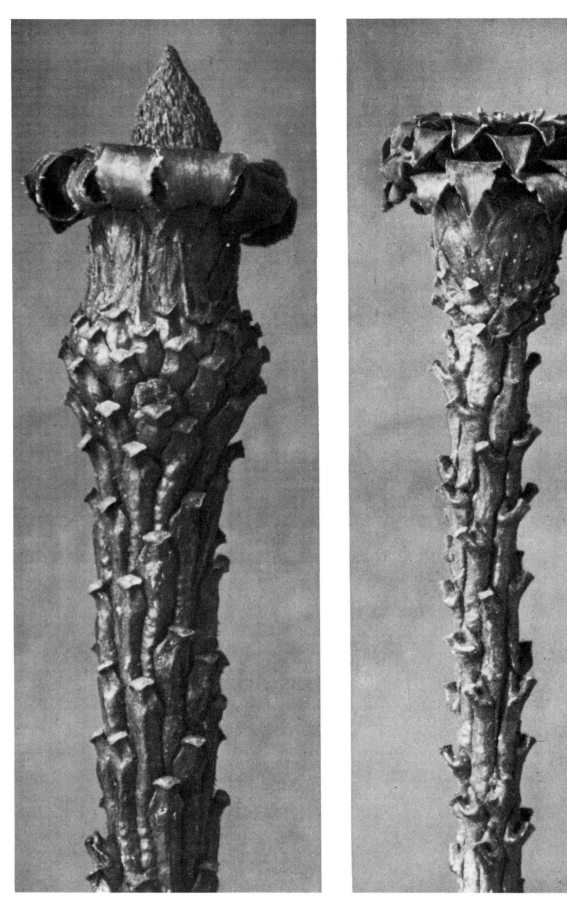

21. *Picea excelsa.* Spruce. Young shoots, with the needles removed, enlarged 9.0 times.

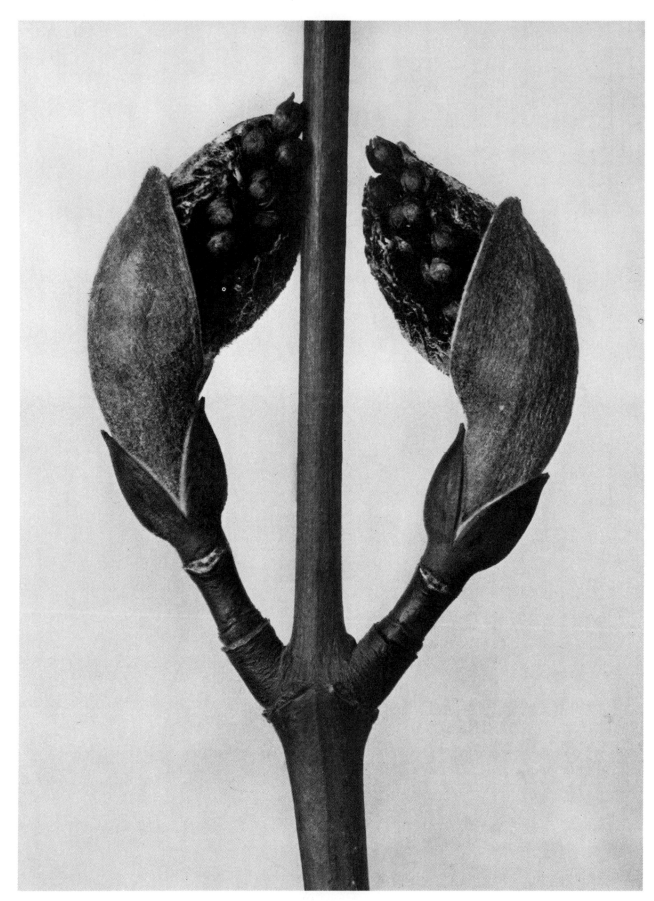

22. *Acer rufinerve*. Maple. Shoot enlarged 9.0 times.

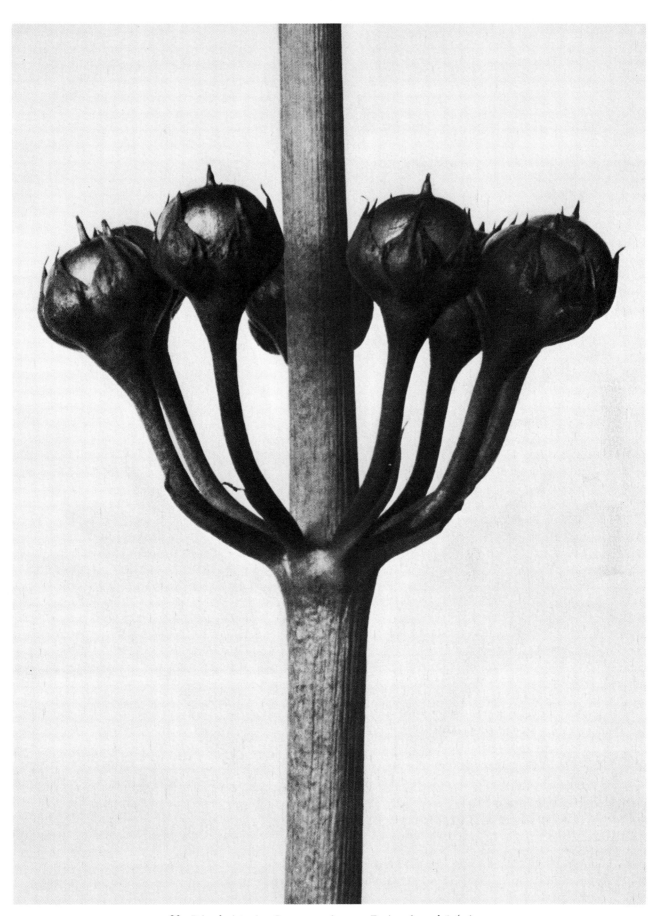

23. *Primula japonica*. Japanese primrose. Fruit enlarged 5.4 times.

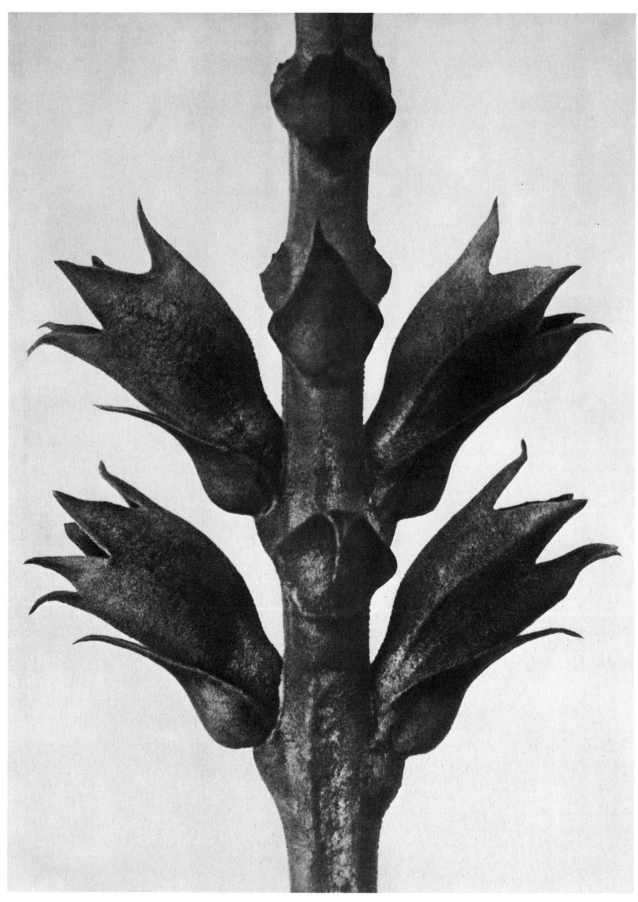

24. *Physostegia virginiana*. Virginian False Dragon-head, Benth. Stem, with calyx and cauline leaves,
    enlarged 13.5 times.

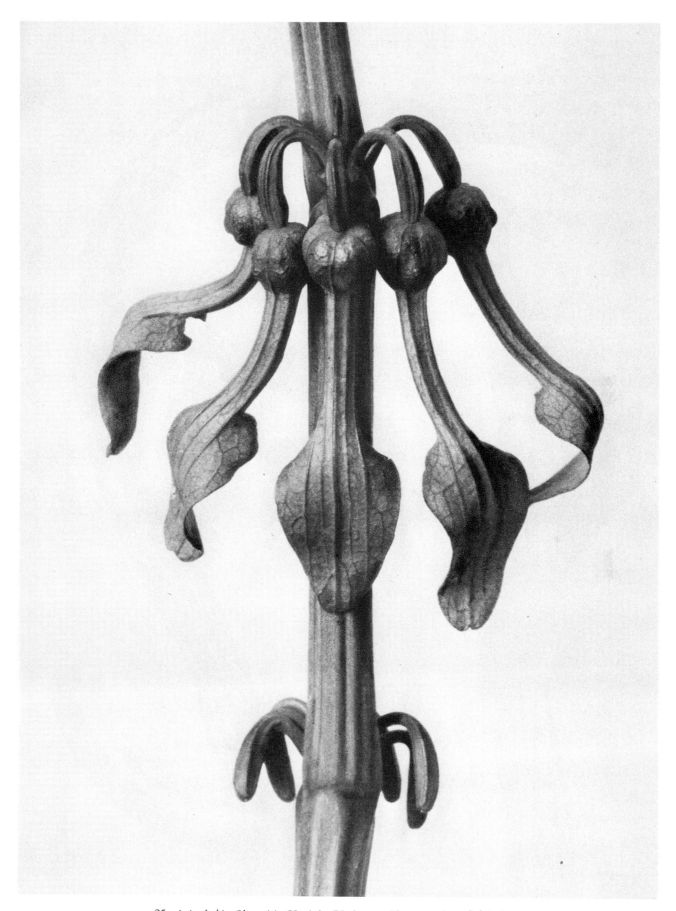

25. *Aristolochia Clematitis*. Upright Birthwort. Flowers enlarged 6.3 times.

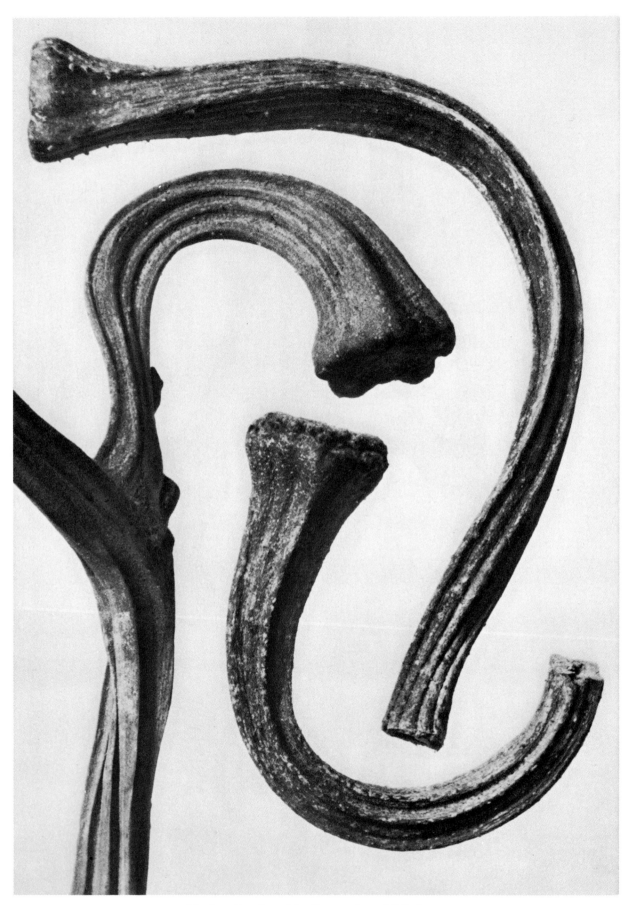

26. *Cucurbita*. Pumpkin. Stems enlarged 2.7 times.

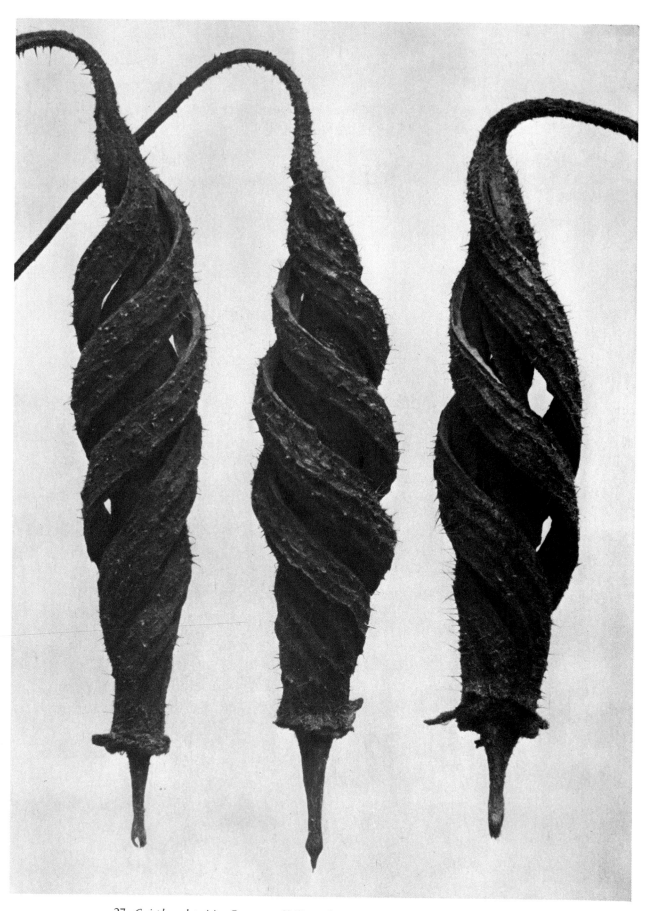

27. *Cajophora lateritia*. Common Chili-nettle. Seminal capsules enlarged 4.5 times.

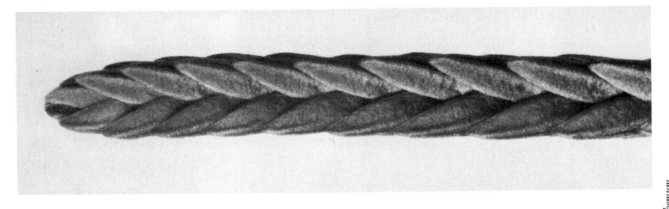

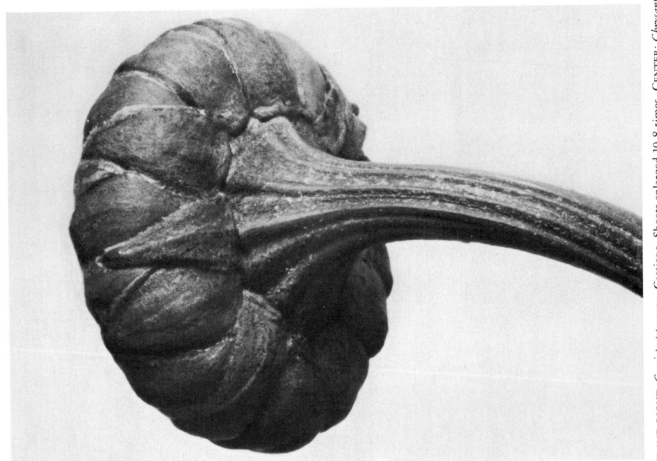

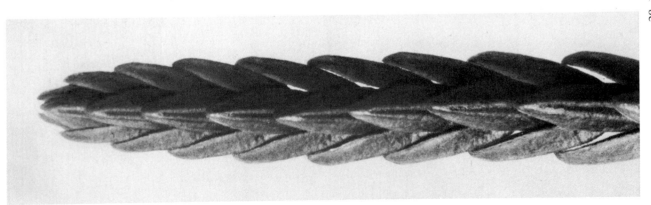

28. LEFT AND RIGHT: *Cassiope tetragona*. Cassiope. Shoots enlarged 10.8 times. CENTER: *Chrysanthemum Leucanthemum*. Ox-eye Daisy. Flower bud enlarged 14.4 times.

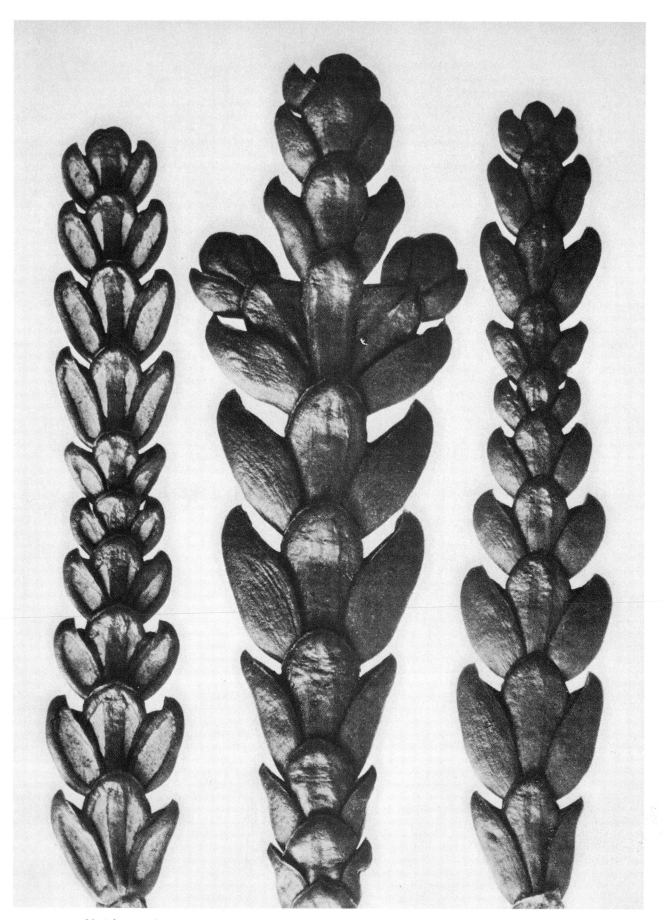

29. *Thujopsis dolabrata*. Hiba Arbor Vitae, False Arbor Vitae. Ends of branches enlarged 9.0 times.

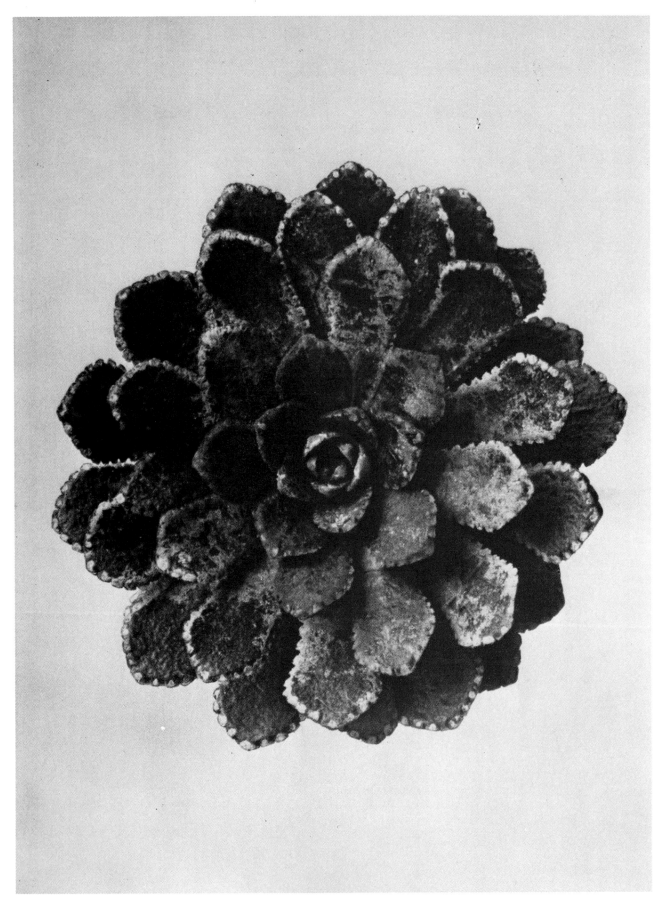

30. *Saxifraga Aizoon*. Saxifrage. Leaf rosette enlarged 7.2 times.

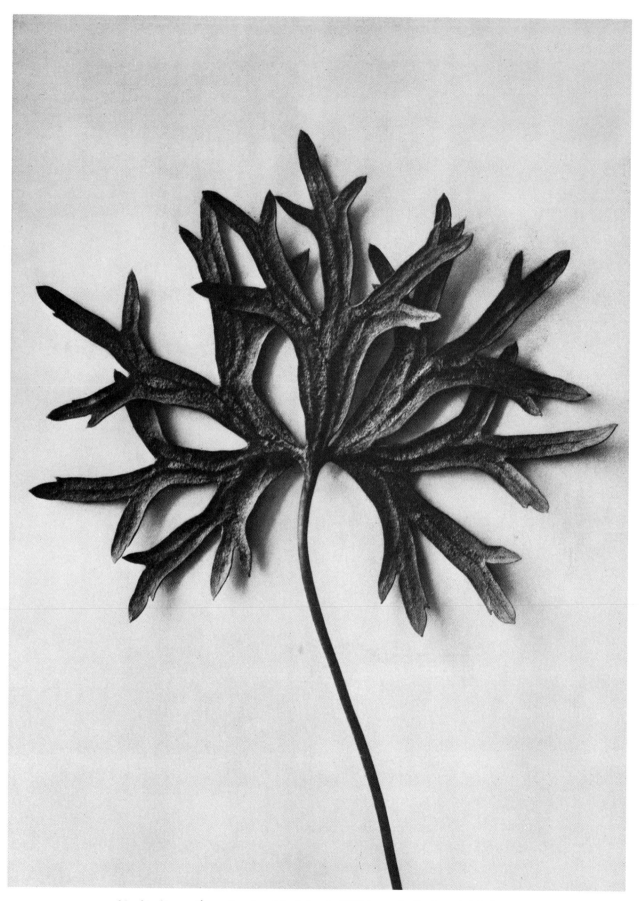

31. *Aconitum anthora*. Aconite, Monkshood, Wolfsbane. Leaf enlarged 2.7 times.

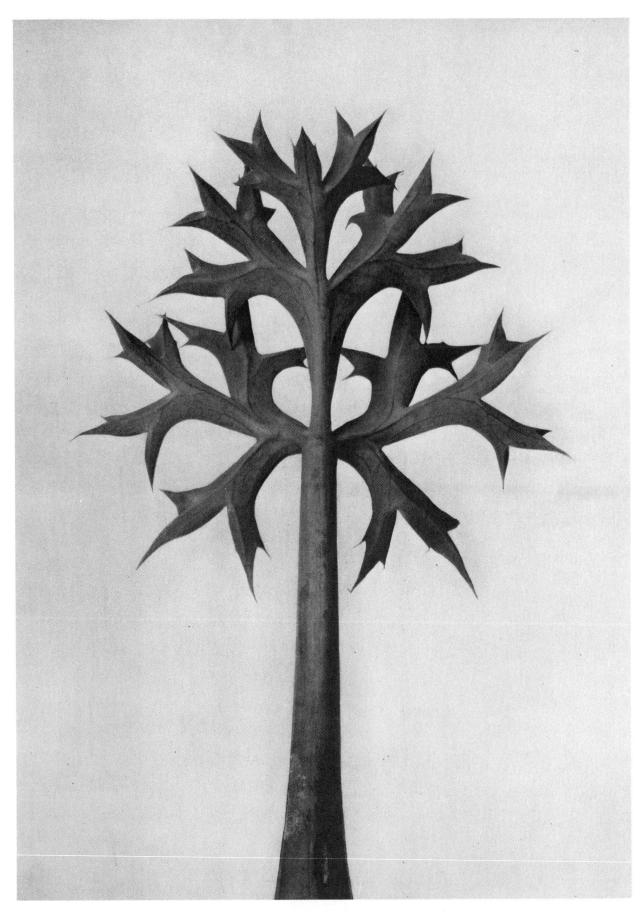

32. *Eryngium Bourgatii*. Bourgati's Eryngo. Leaf enlarged 4.5 times.

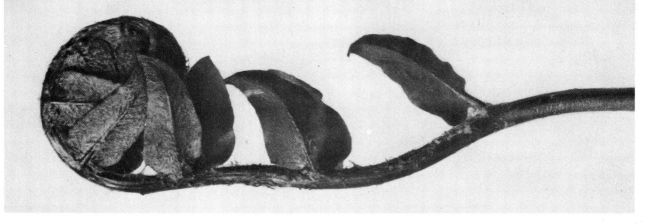

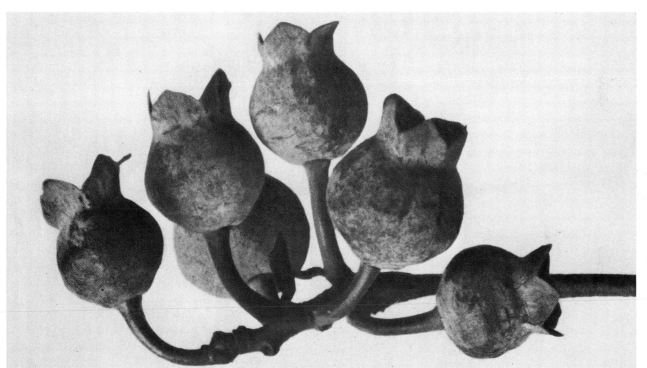

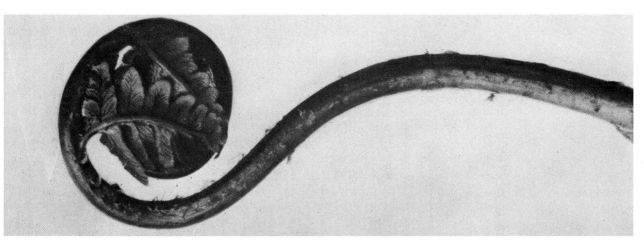

33. LEFT: *Polypodium Aspidium*. Polypody. Rolled-up frond enlarged 3.6 times. CENTER: *Vaccinium corymbosum*. Highbush- or Swamp-Blueberry. Bunch of fruit enlarged 7.2 times. RIGHT: *Polystichum falcatum*. Shield-Fern, Holly-Fern. Young rolled-up frond enlarged 4.5 times.

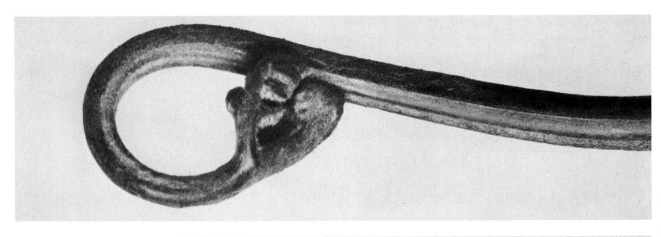

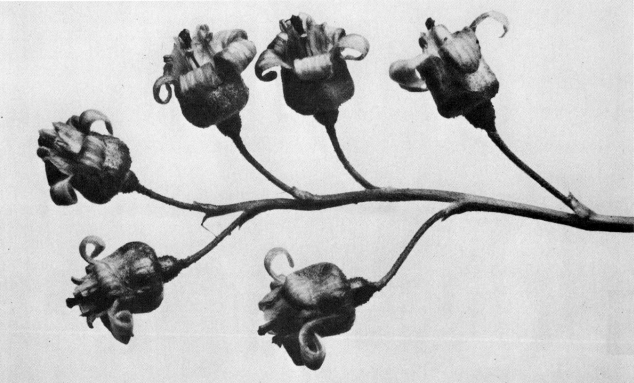

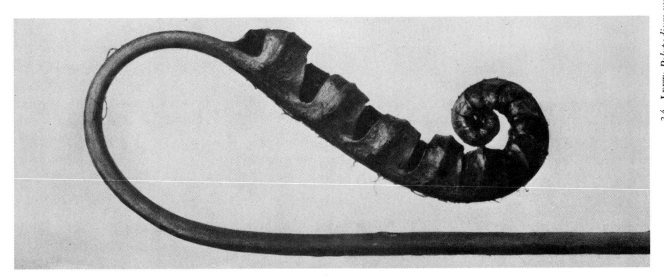

34. LEFT: *Polypodium vulgare*. Common or Golden Polypody, Snake-Fern. Young frond enlarged 6.3 times. CENTER: *Ribes nigrum*. Common Black Currant. Raceme enlarged 4.5 times. RIGHT: *Pteridium aquilinum*. Brake, Pasture-Brake, Hog-Brake. Young frond enlarged 4.5 times.

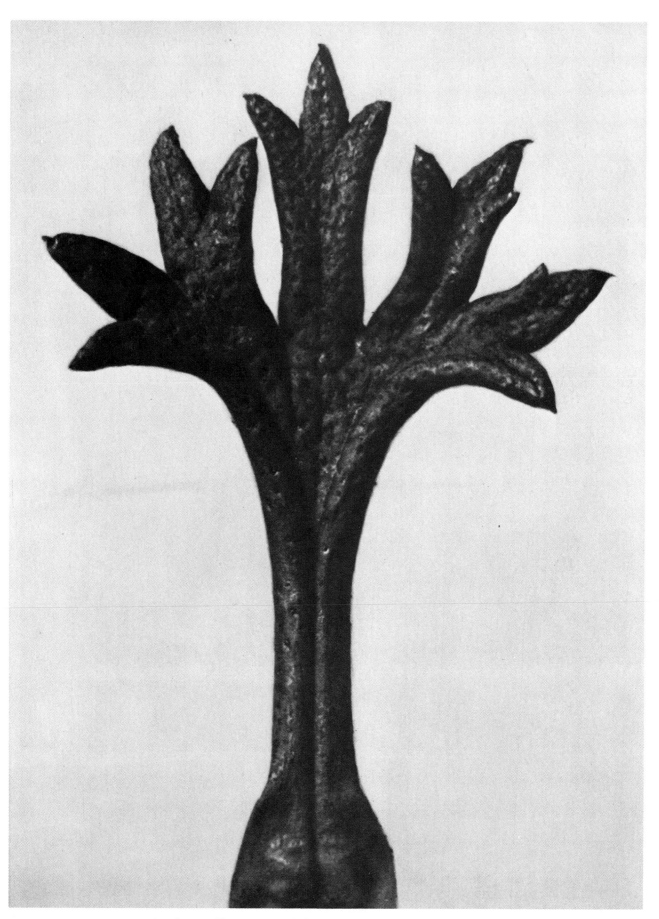

35. *Saxifraga Willkommniana*. Willkomm's Saxifrage. Leaf enlarged 16.2 times.

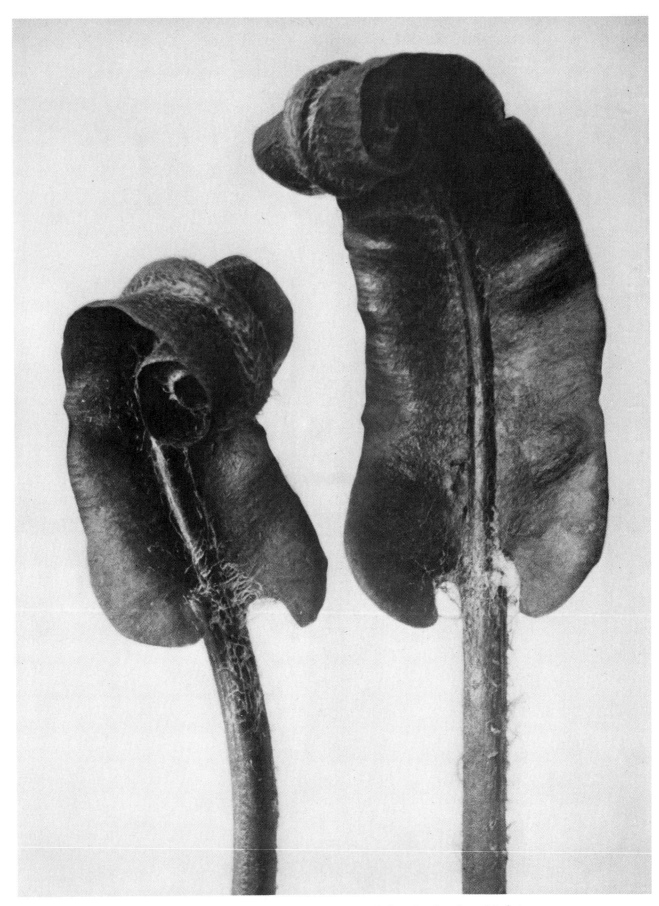

36. *Scolopendrium vulgare*. Hart's-tongue-Fern. Young rolled-up fronds enlarged 5.4 times.

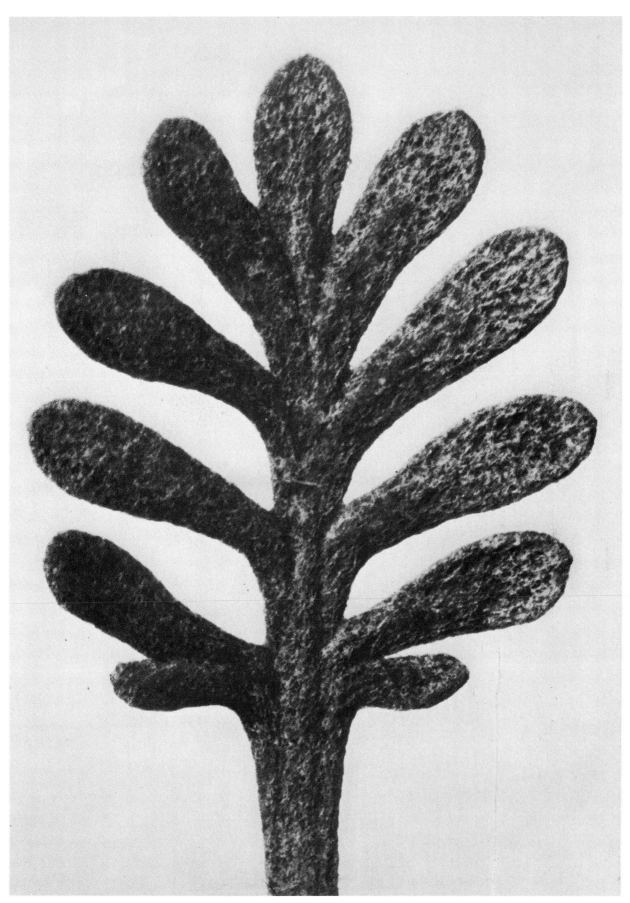

37. *Achillea umbellata*. Yarrow. Leaf enlarged 27.0 times.

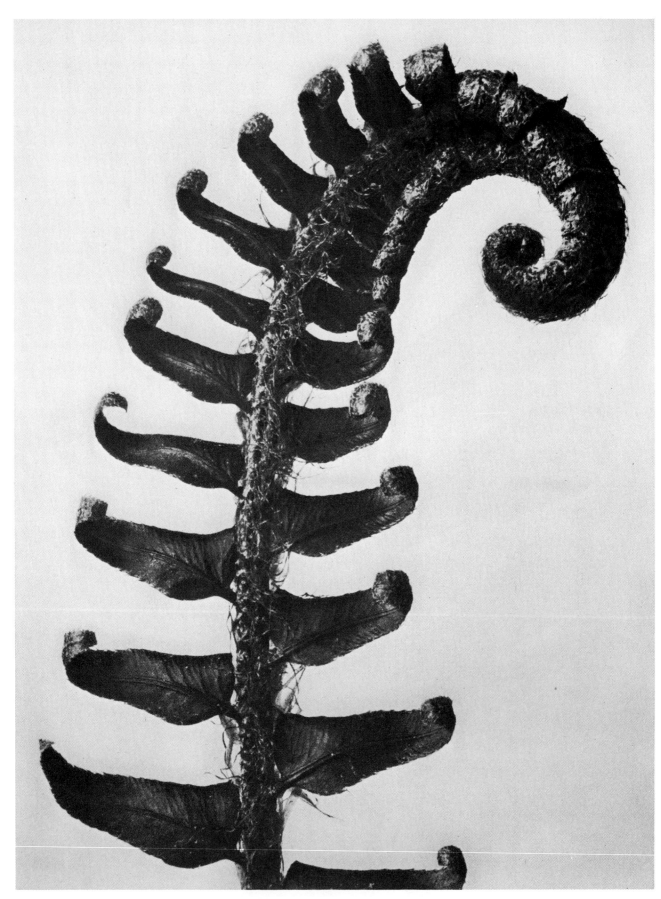

38. *Polystichum munitum.* Shield-Fern. Young rolled-up frond enlarged 5.4 times.

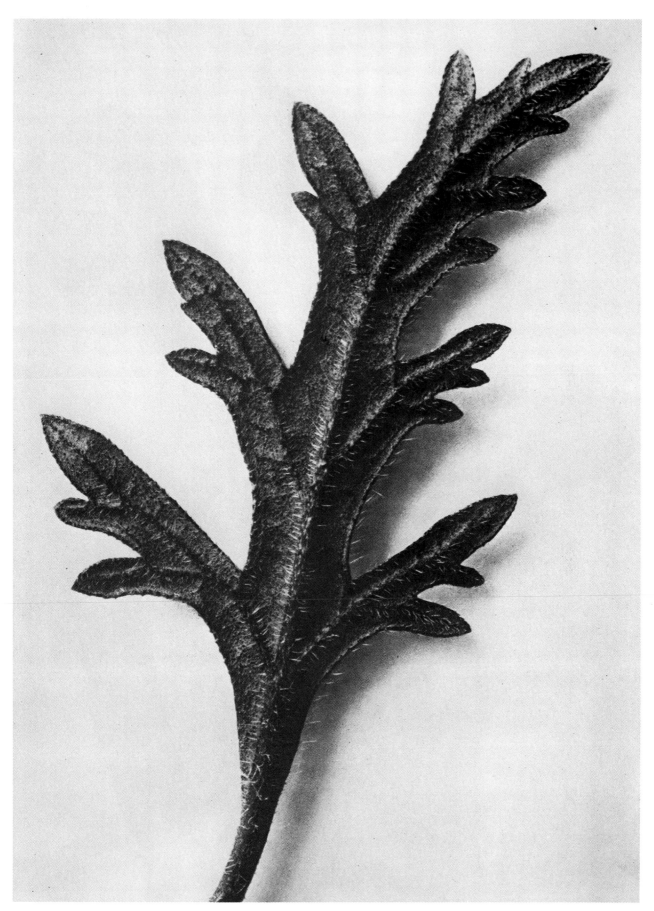

39. *Verbena canadensis*. Canadian Rose-Vervain. Leaf enlarged 9.0 times.

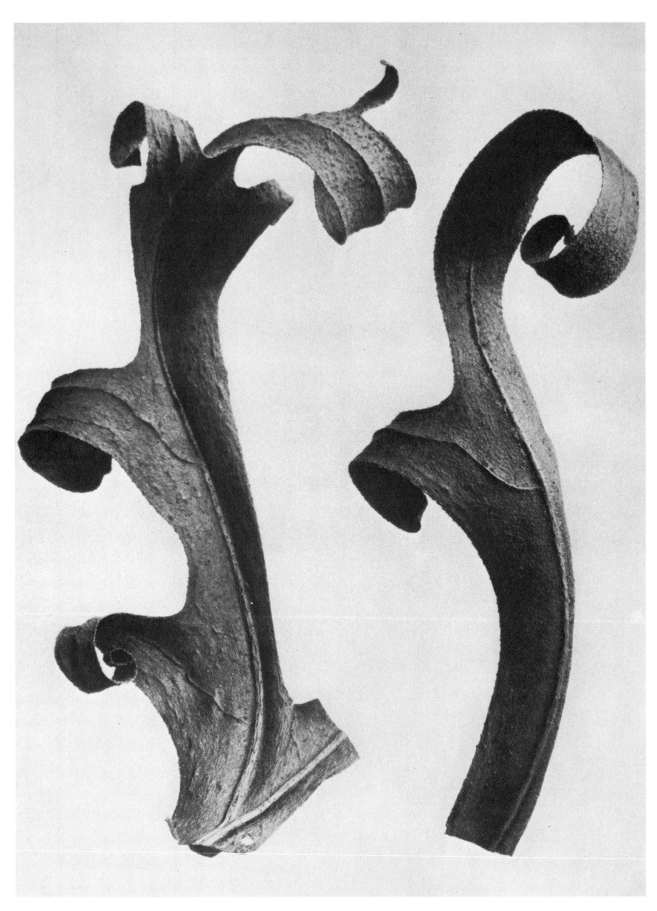

40. *Silphium laciniatum*. Compass-plant, Rosinweed. Parts of leaf dried on the stem enlarged 5.4 times.

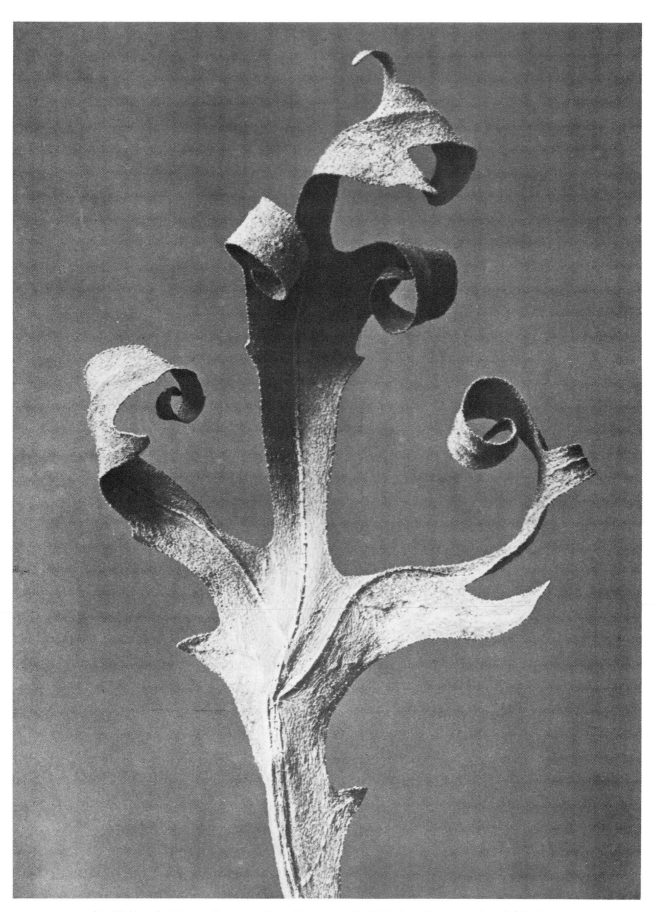

41. *Silphium laciniatum*. Compass-plant, Rosinweed. Leaf dried on the stem enlarged 4.5 times.

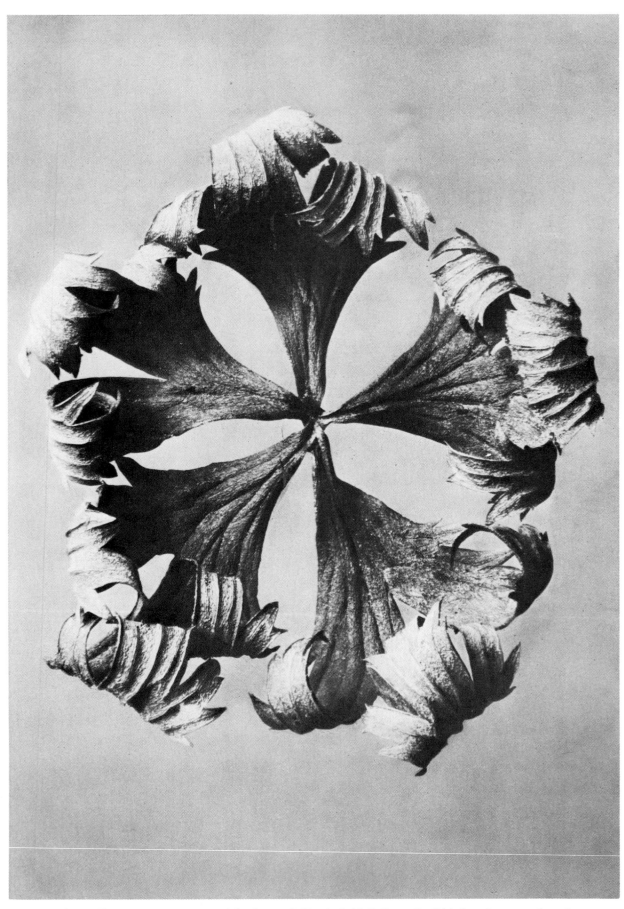

42. *Trollius europaeus*. Common Globe-flower, Golden-ball, Troll-flower. Leaf dried on the stem enlarged 4.5 times.

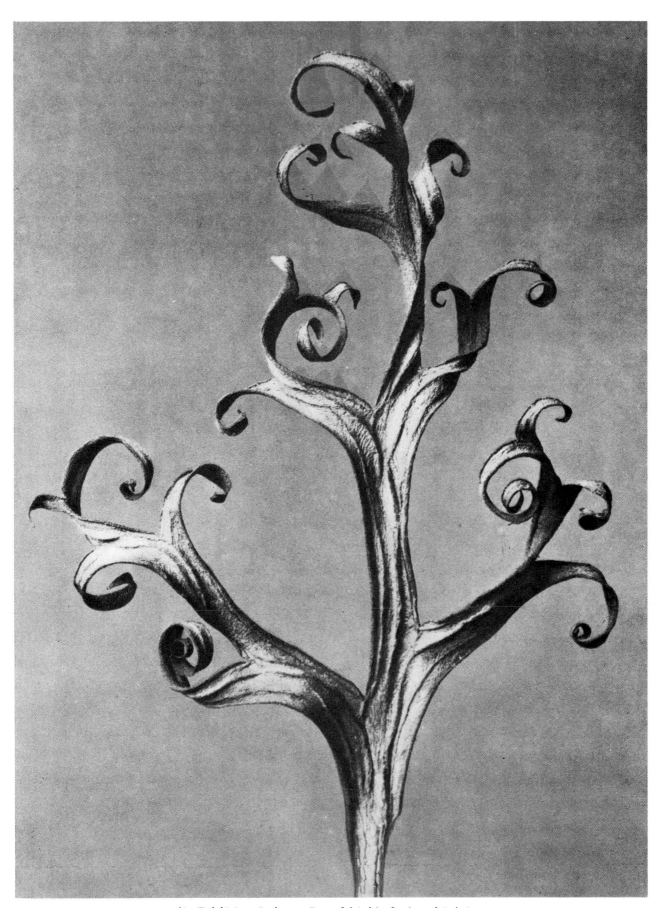

43. *Delphinium*. Larkspur. Part of dried leaf enlarged 5.4 times.

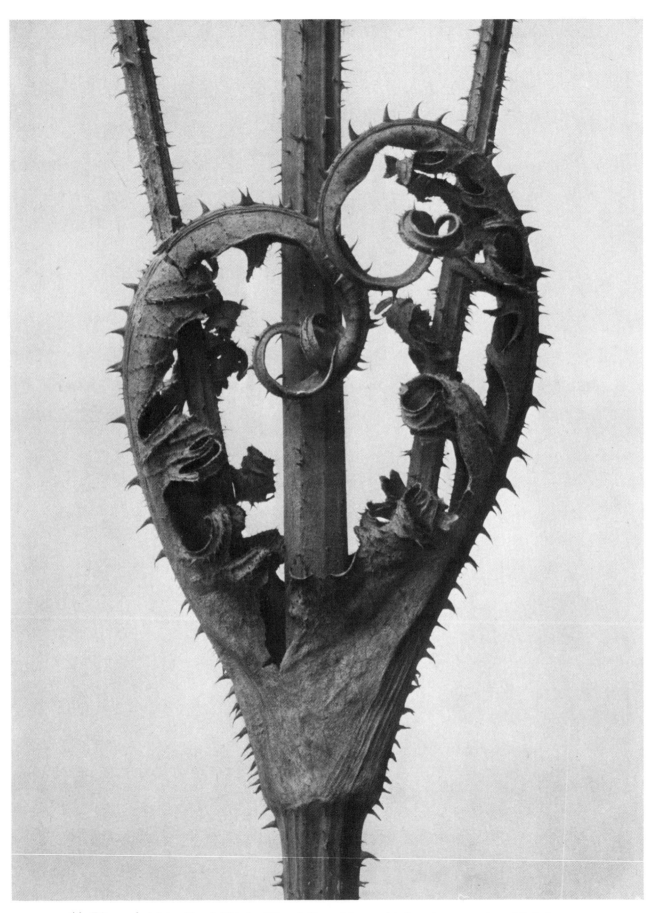

44. *Dipsacus laciniatus.* Teasel, Thistle, "Venus's Bason." Leaves dried on the stem enlarged 3.6 times.

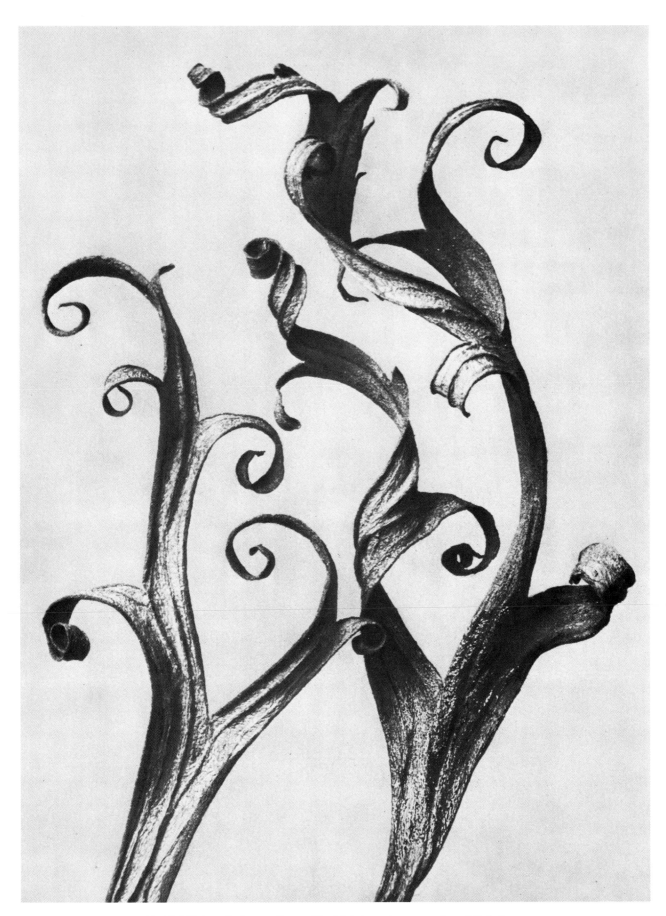

45. *Delphinium*. Larkspur. Parts of leaf dried on the stem enlarged 5.4 times.

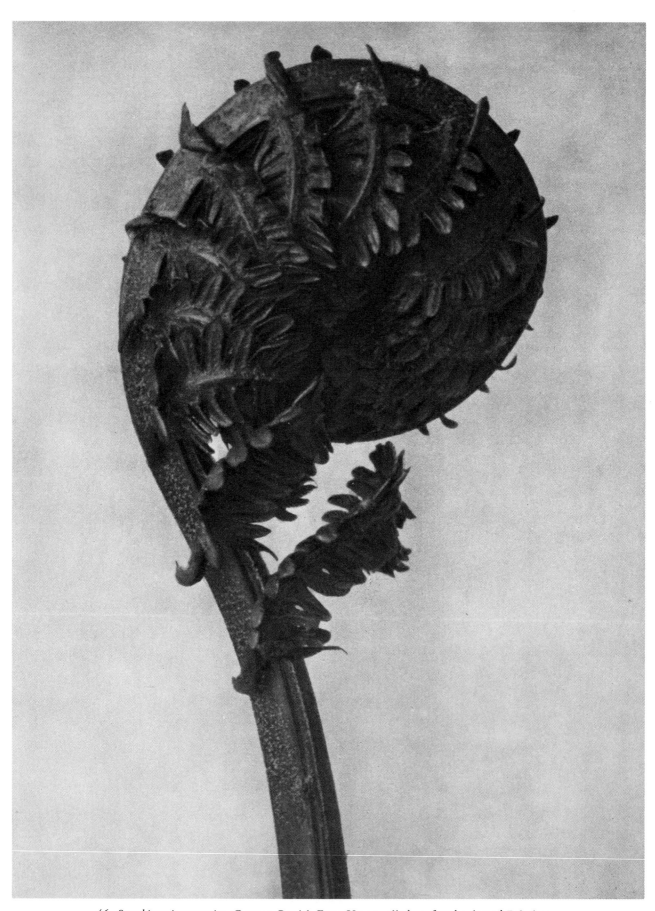

46. *Struthiopteris germanica.* German Ostrich-Fern. Young rolled-up frond enlarged 7.2 times.

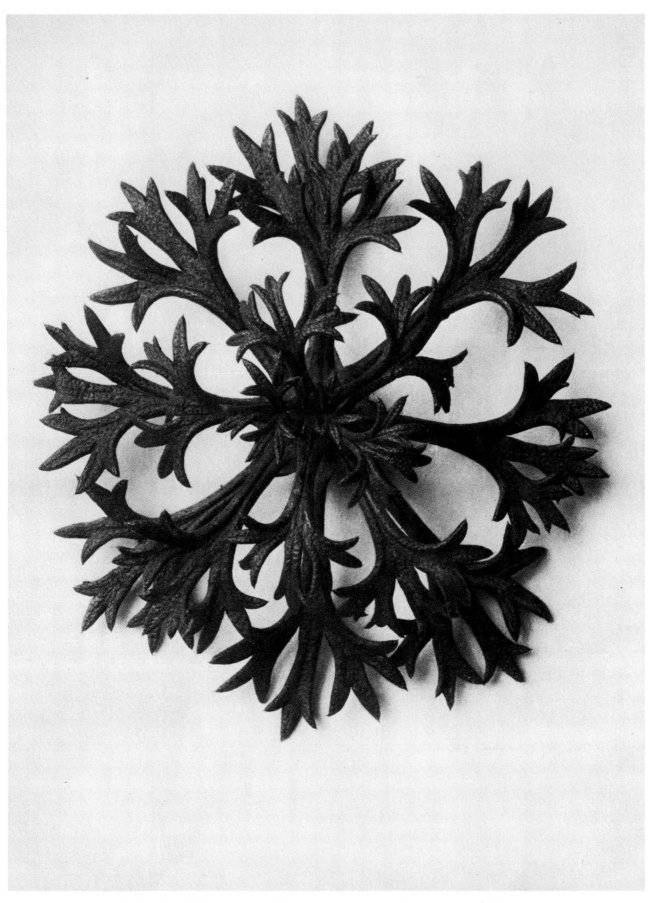

47. *Saxifraga Willkommniana*. Willkomm's Saxifrage. Leaf-rosette enlarged 7.2 times.

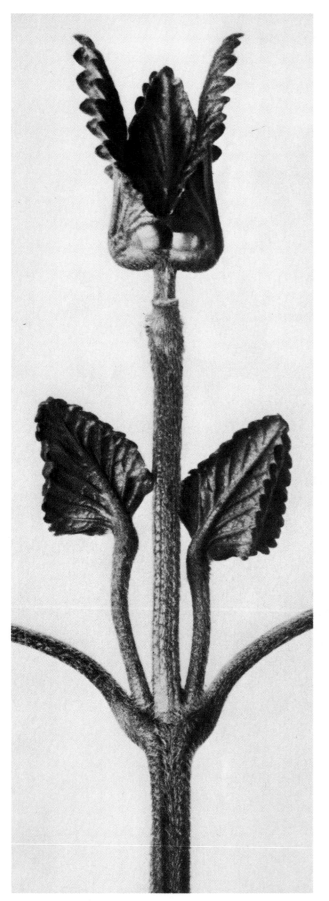 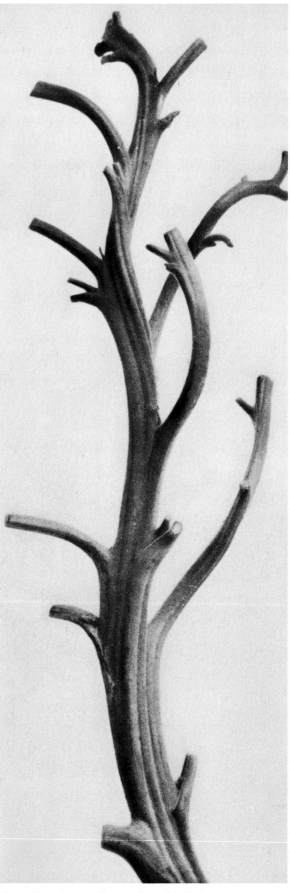

48. LEFT: *Stachys grandiflora.* Large-flowered Hedge-Nettle or Woundwort. Shoot enlarged 2.7 times.
RIGHT: *Nicotiana rustica.* Wild Tobacco. Stem reduced 0.1 time.

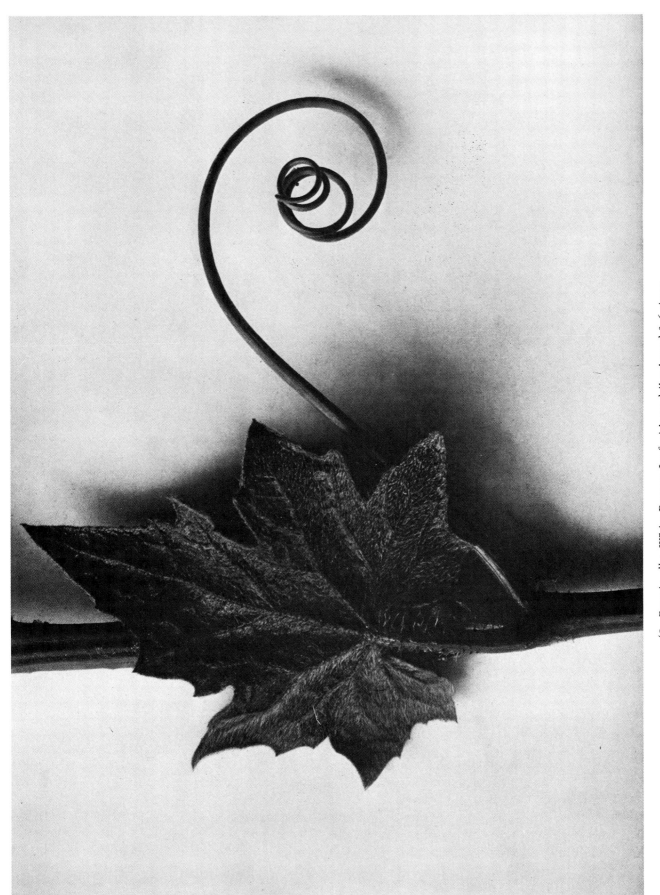

49. *Bryonia alba.* White Bryony. Leaf with tendril enlarged 3.6 times.

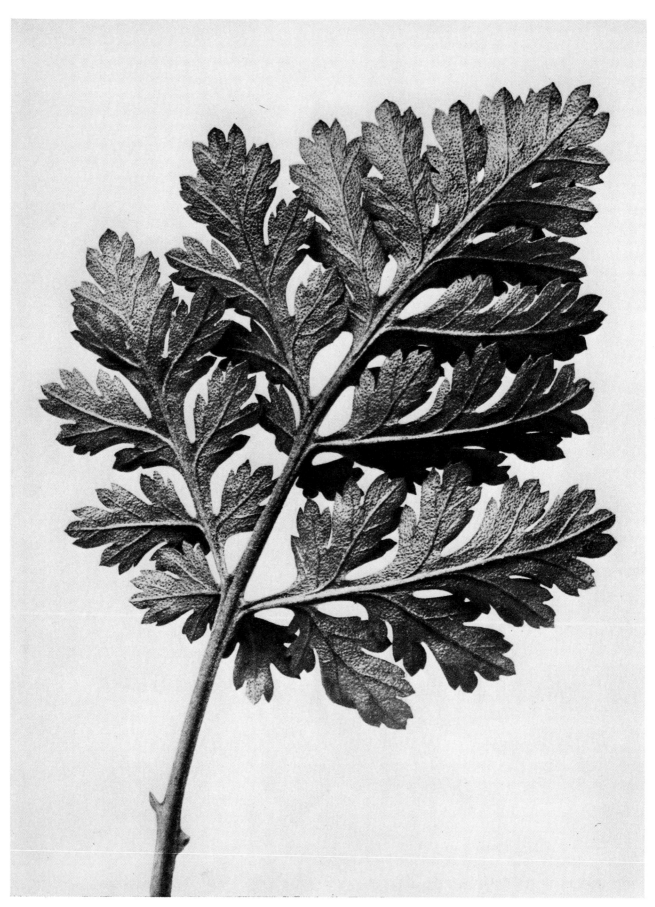

50. *Chrysanthemum Parthenium.* Feverfew. Leaf enlarged 4.5 times.

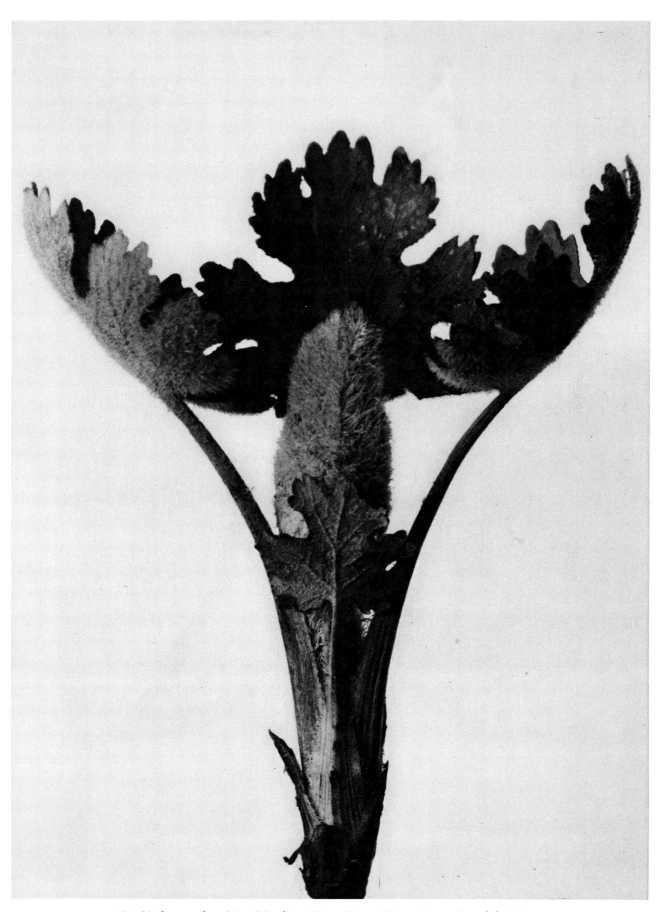

51. *Macleaya cordata*. Tree-Celandine, Plume-Poppy. Young shoot enlarged 4.5 times.

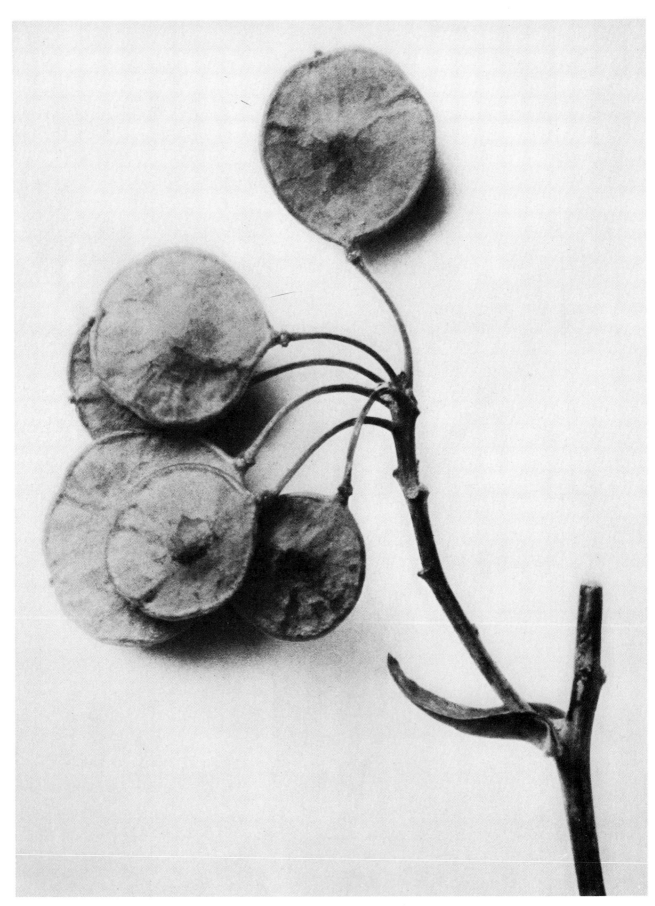

52. *Ptelea trifoliata*. Three-leaved Hop-tree, Shrubby Trefoil, Stinking Ash, Water-Ash. Branch with fruit enlarged 5.4 times.

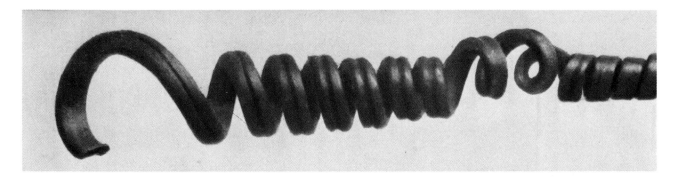

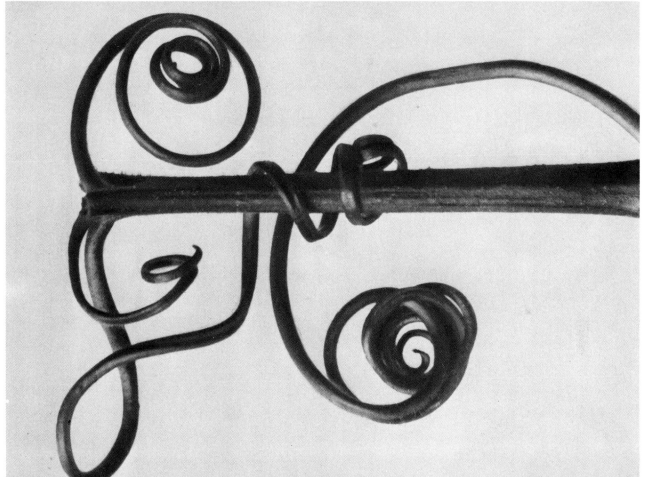

53. *Cucurbita*. Pumpkin. Tendrils enlarged 3.6 times.

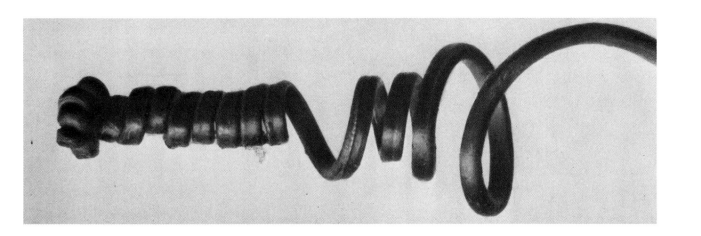

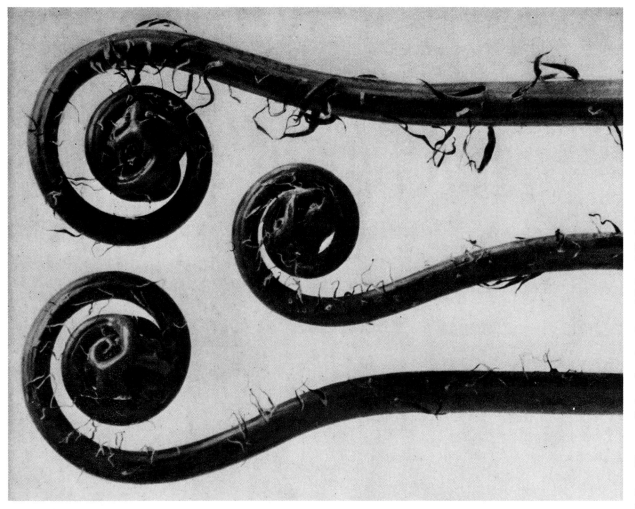

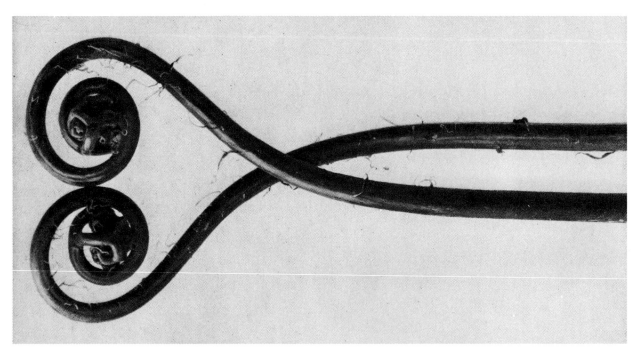

54. *Adiantum pedatum*. Maidenhair-Fern. Young rolled-up fronds enlarged 7.2 and 10.8 times.

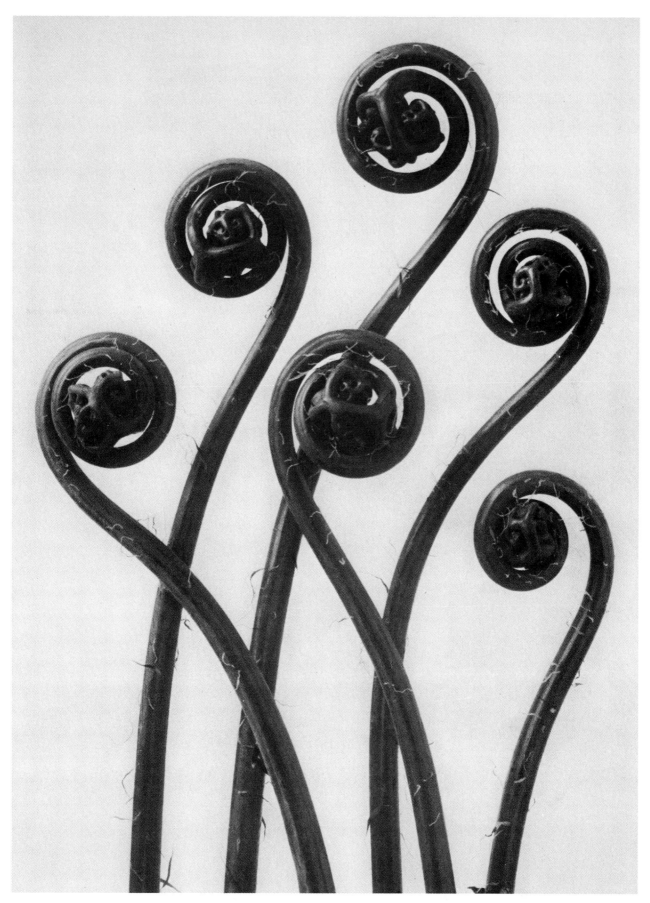

55. *Adiantum pedatum*. Maidenhair-Fern. Young rolled-up fronds enlarged 7.2 times.

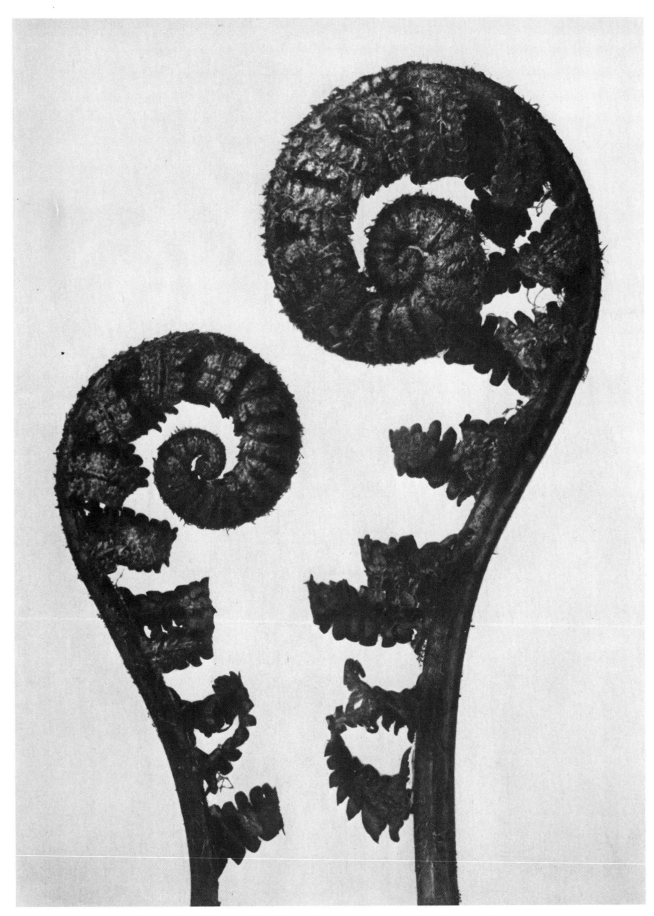

56. *Aspidium filix mas*. Shield-Fern. Young rolled-up fronds enlarged 3.6 times.

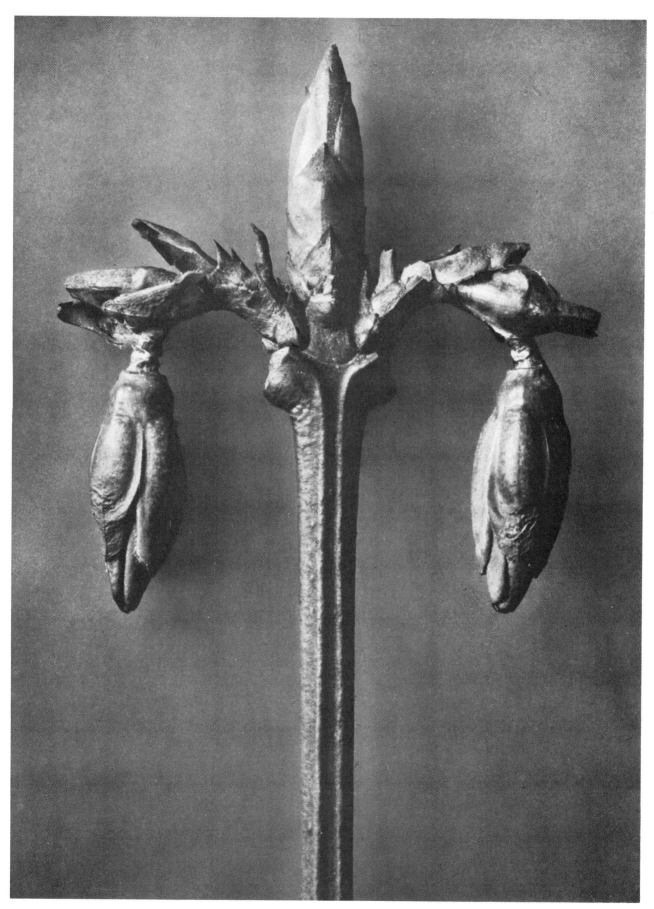

57. *Forsythia suspensa*. Weeping Forsythia. Young shoot enlarged 9.0 times.

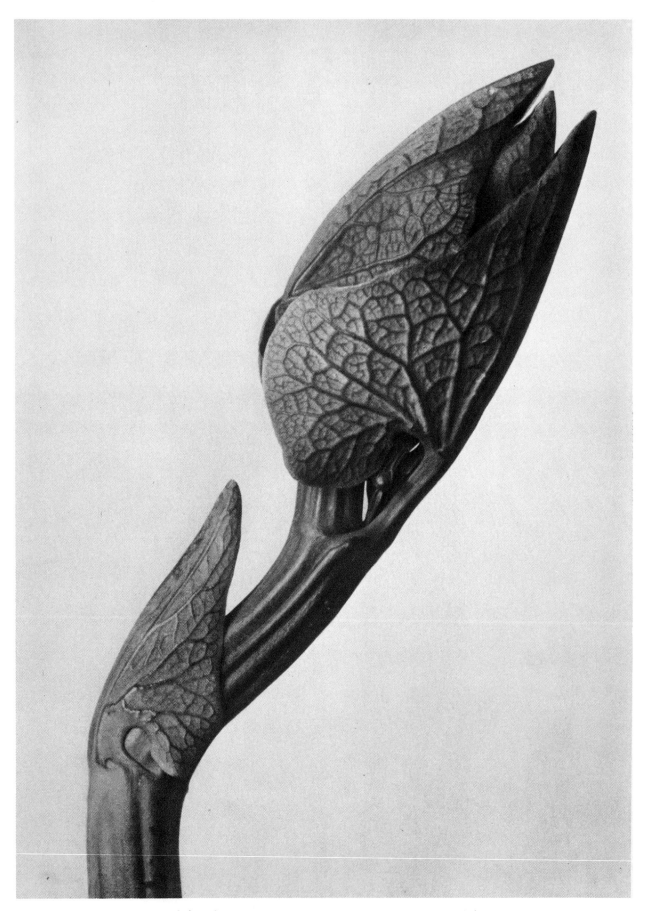

58. *Aristolochia Clematitis*. Upright Birthwort. Young shoot enlarged 4.5 times.

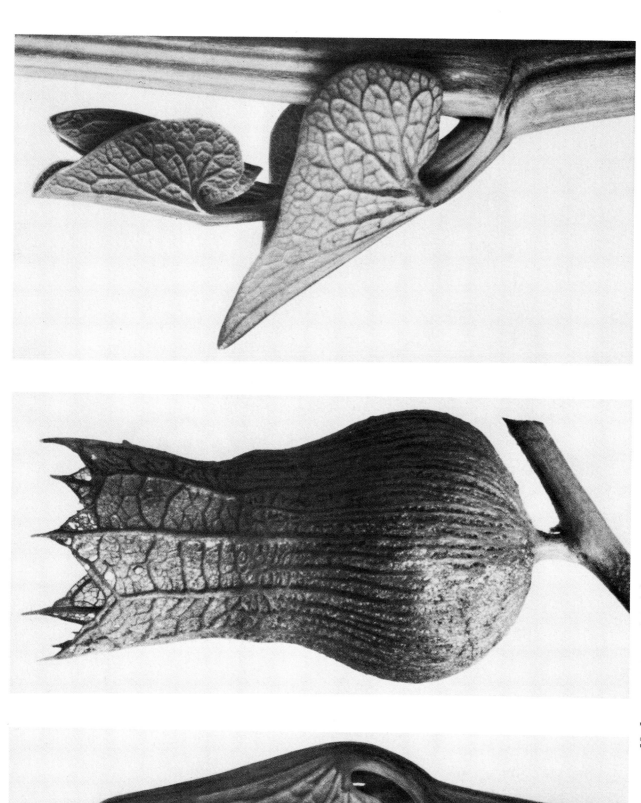

59. LEFT AND RIGHT: *Aristolochia Clematitis.* Upright Birthwort. Stems with leaves enlarged 7.2 times. CENTER: *Hyoscyamus niger.* Black Henbane. Seminal capsule enlarged 9.0 times.

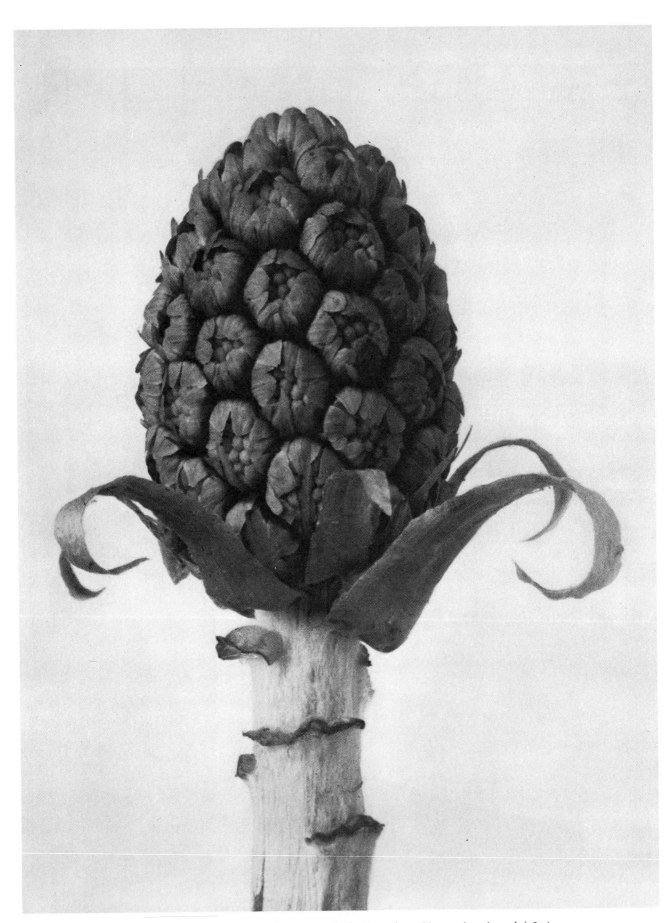

60. *Petasites officinalis*. Batter-dock, Bog Rhubarb, Butterbur. Glomerule enlarged 4.5 times.

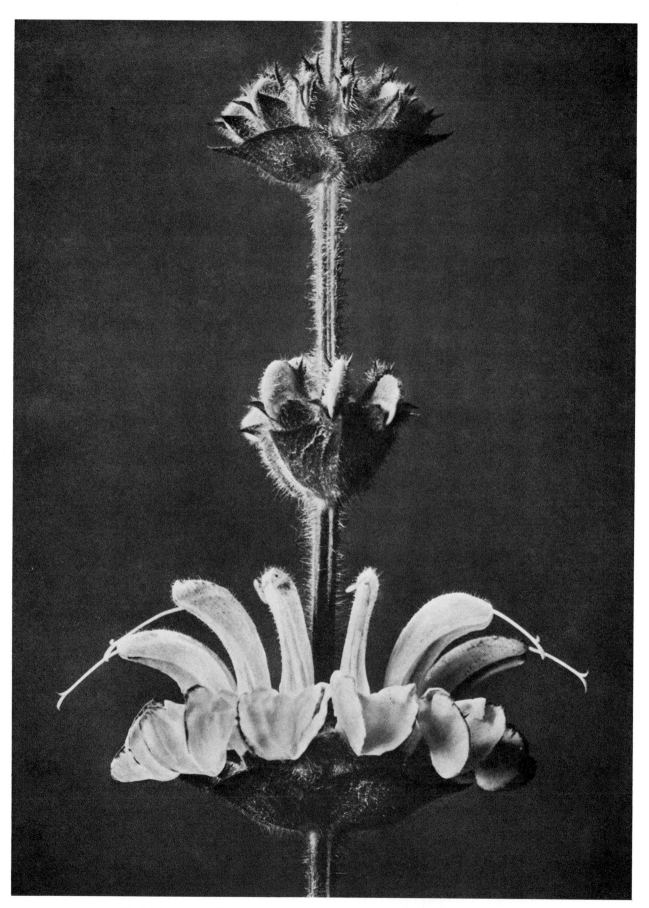

61. *Salvia argentea*. Silver-leaved Sage. Part of flowering plant enlarged 3.6 times.

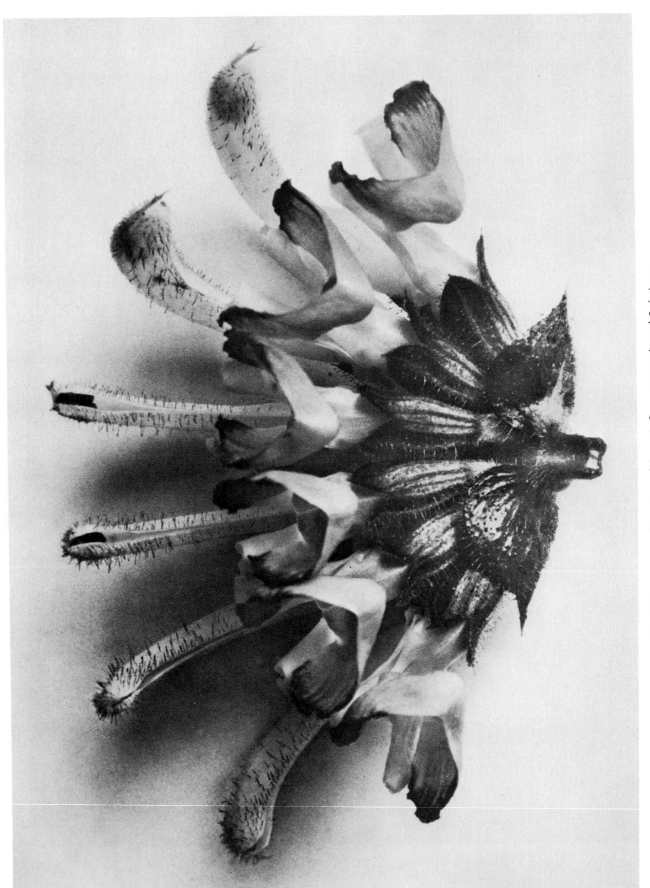

62. *Salvia argentea.* Silver-leaved Sage. Inflorescence enlarged 5.4 times.

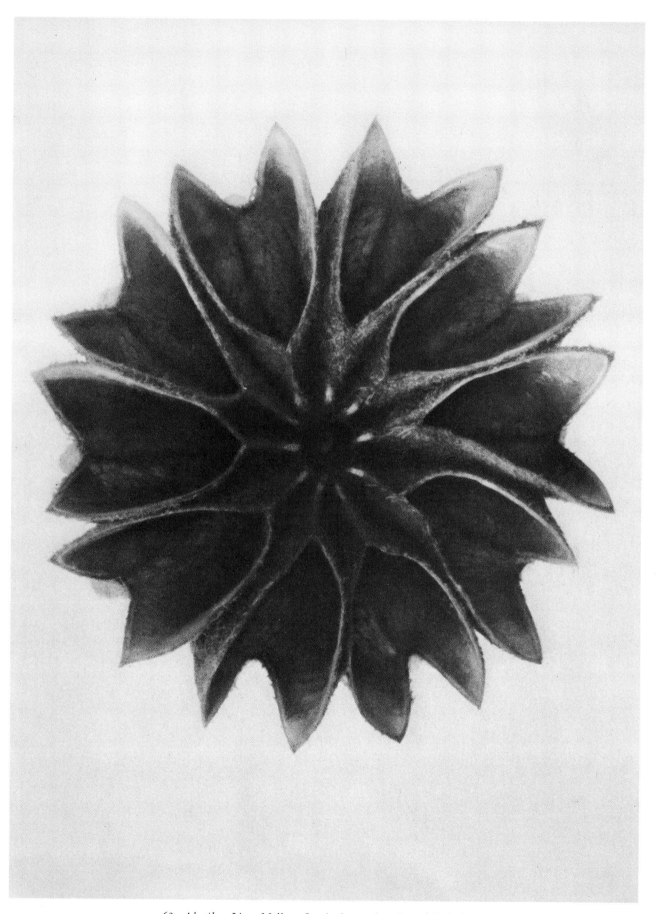

63. *Abutilon.* Lime Mallow. Seminal capsule enlarged 10.8 times.

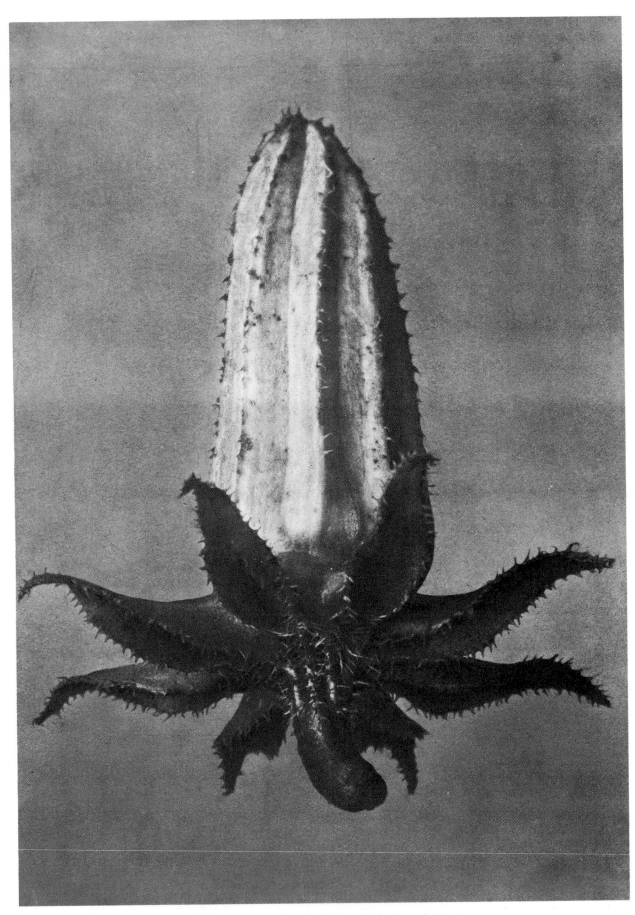

64. *Mindium campanuloides*. Bellflower. Bud enlarged 7.2 times.

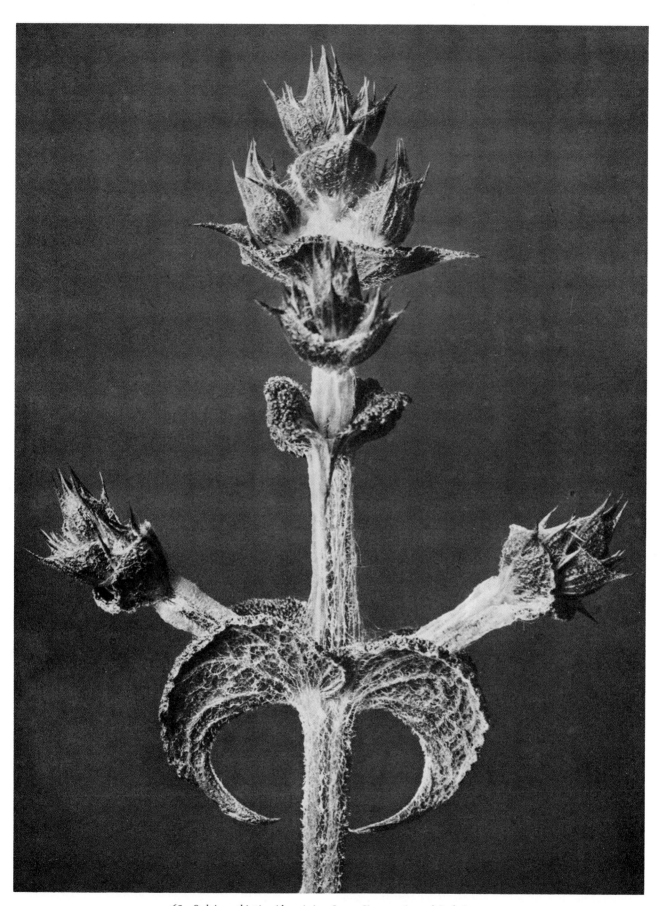

65. *Salvia aethiopis*. Abyssinian Sage. Shoot enlarged 3.6 times.

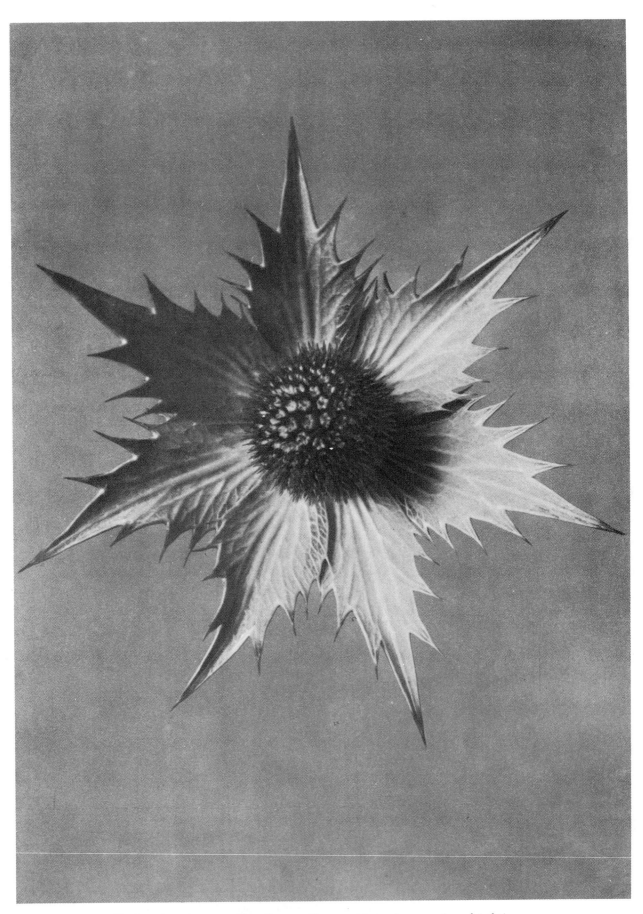

66. *Eryngium giganteum*. Giant Eryngo. Flower, with involucres, enlarged 3.6 times.

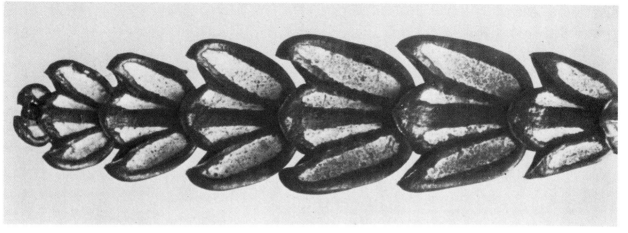

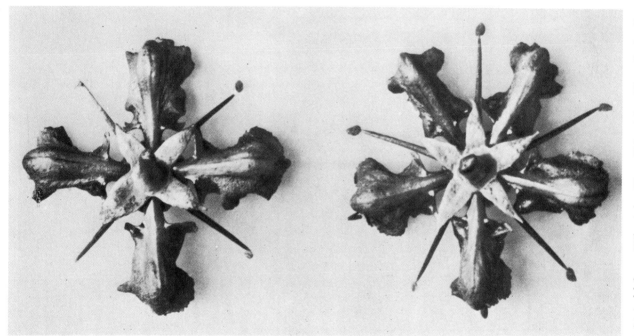

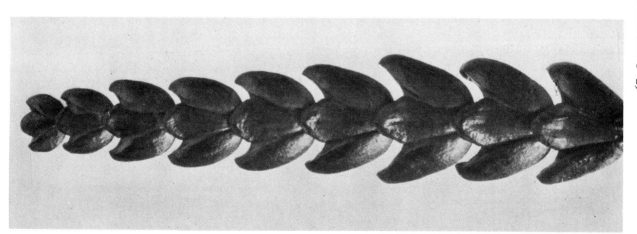

67.  LEFT AND RIGHT: *Thujopsis dolabrata.* Hiba Arbor Vitae, False Arbor Vitae. Ends of branches enlarged 9.0 times.
CENTER: *Ruta graveolens.* Common Rue, Herb-of-grace. Flower enlarged 7.2 times.

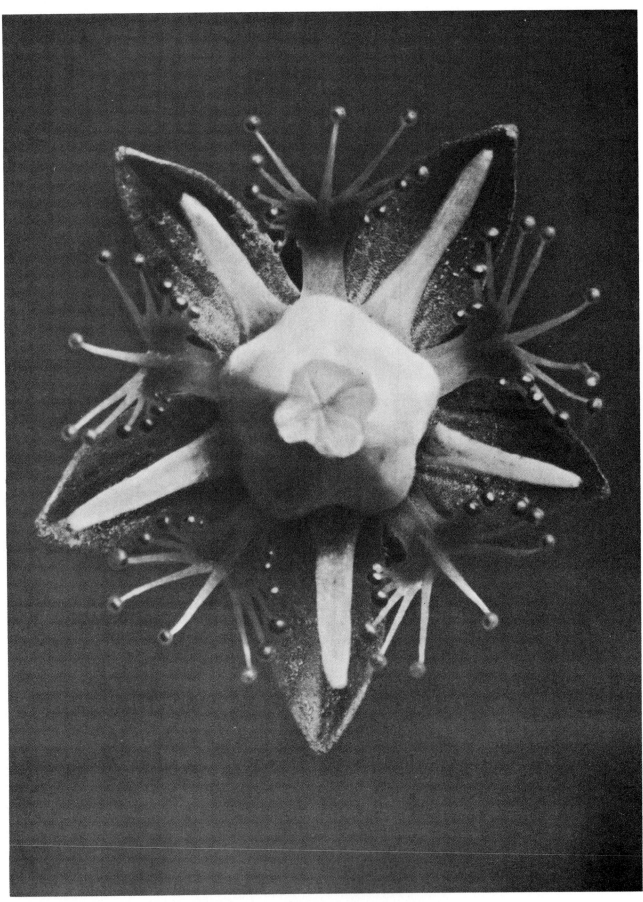

68. *Parnassia palustris*. Common Grass-of-Parnassus. Inner parts of the flower, with the outer petals removed, enlarged 22.5 times.

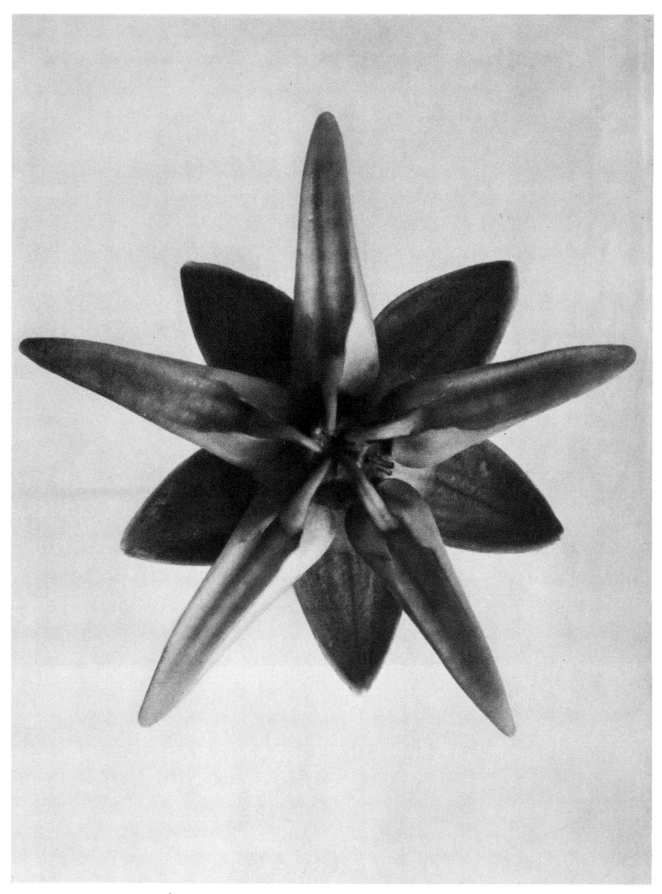

69. *Asclepias speciosa*. Showy Milkweed. Flower enlarged 9.0 times.

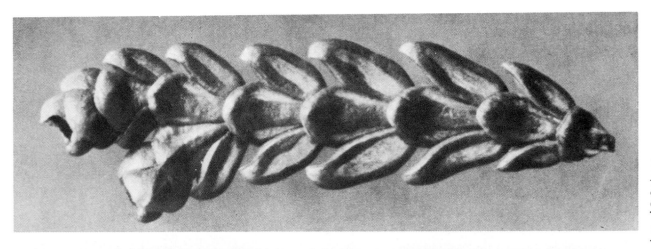

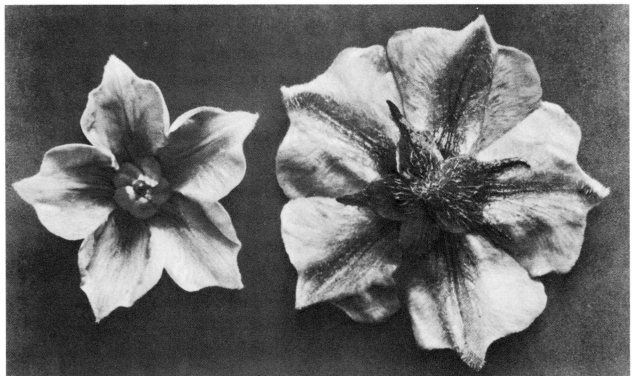

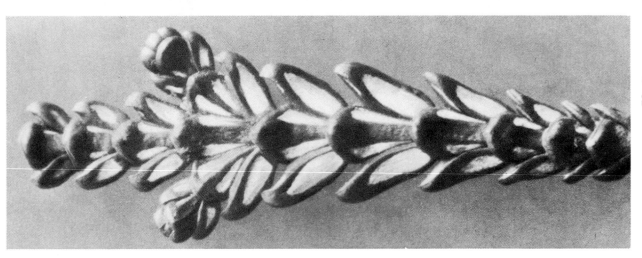

70. LEFT AND RIGHT: *Thujopsis dolabrata*. Hiba Arbor Vitae, False Arbor Vitae. Ends of branches enlarged 9.0 times.
CENTER: *Solanum tuberosum*. Potato. Flowers enlarged 4.5 times.

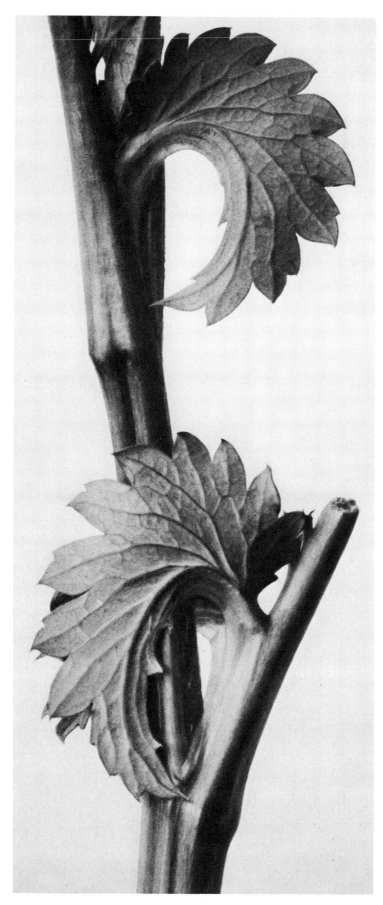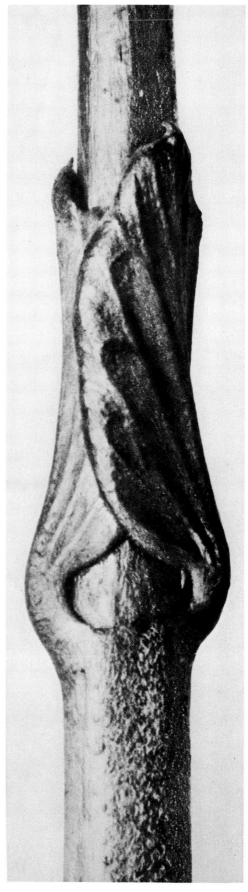

71. LEFT: *Sanguisorba canadensis*. Canadian Great Burnet. Stem, with stipules, enlarged 7.2 times.
RIGHT: *Vincetoxicum fuscatum*. Vincetoxicum. Lower stem, with young leaves, enlarged 13.5 times.

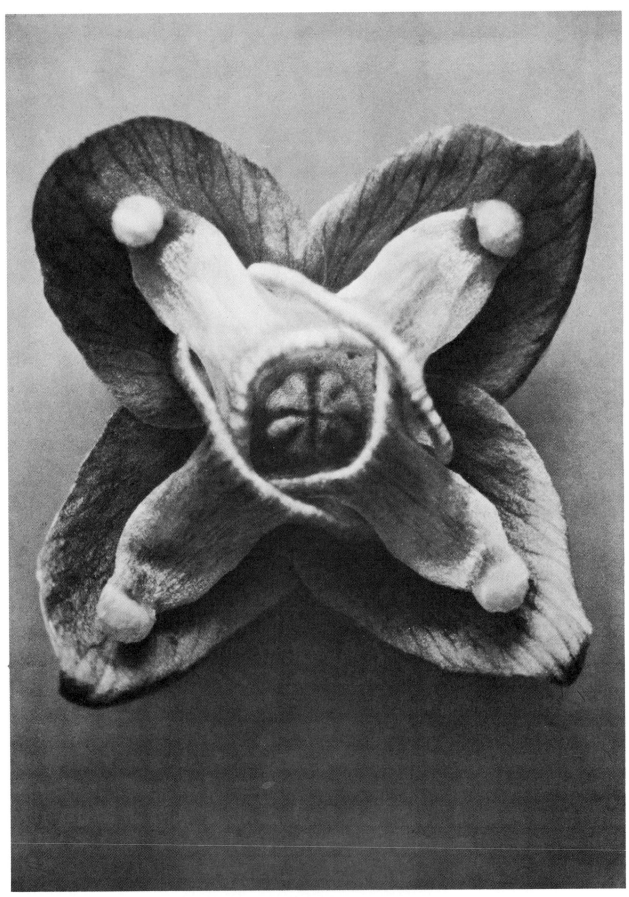

72. *Epimedium Muschianum*. Muschi's Barrenwort. Flower enlarged 21.6 times.

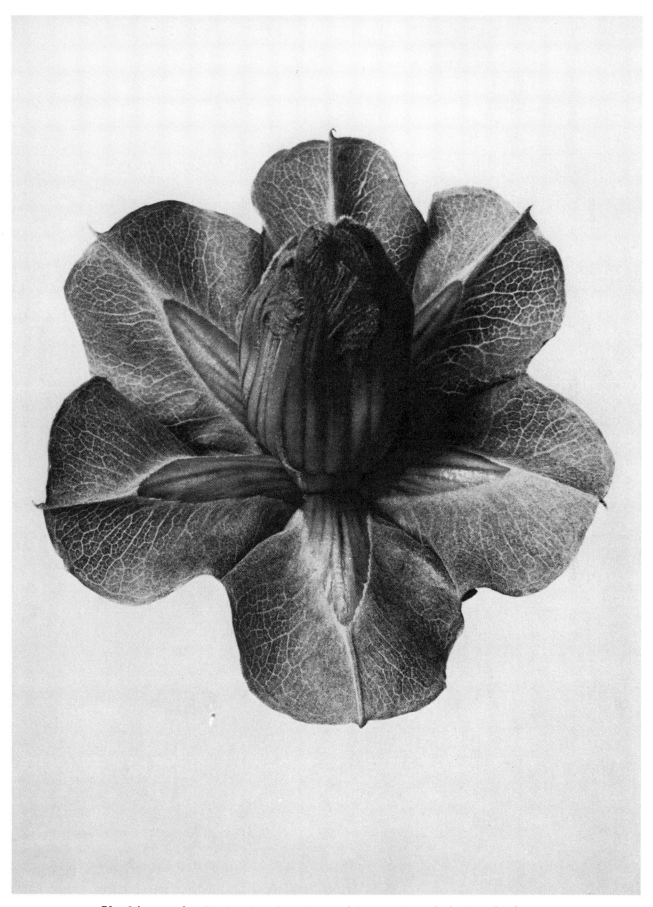

73. *Cobaea scandens*. Mexican Ivy-plant, Cups-and-Saucers. Flower bud enlarged 3.6 times.

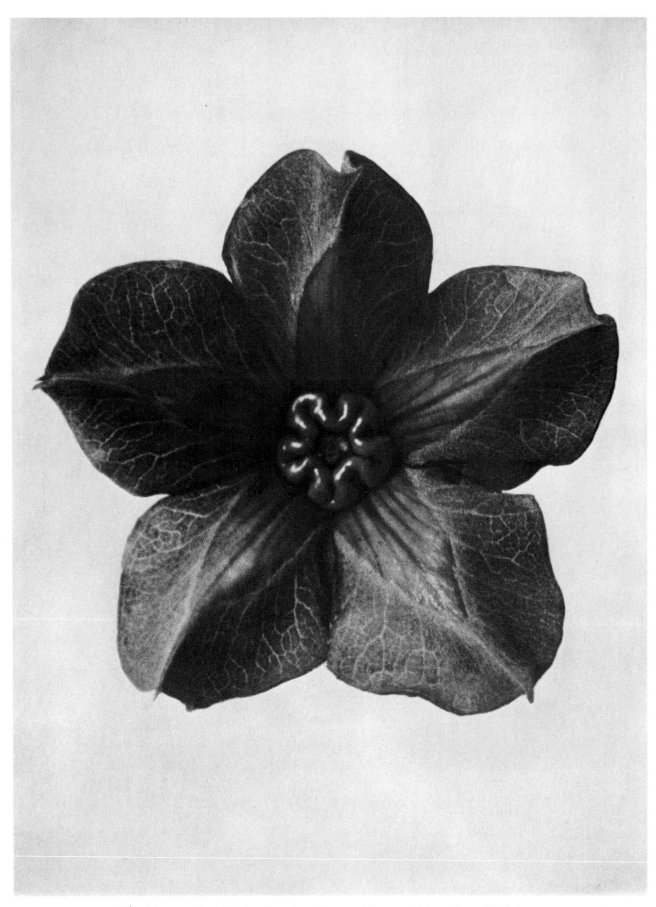

74. *Cobaea scandens*. Mexican Ivy-plant, Cups-and-Saucers. Calyx enlarged 3.6 times.

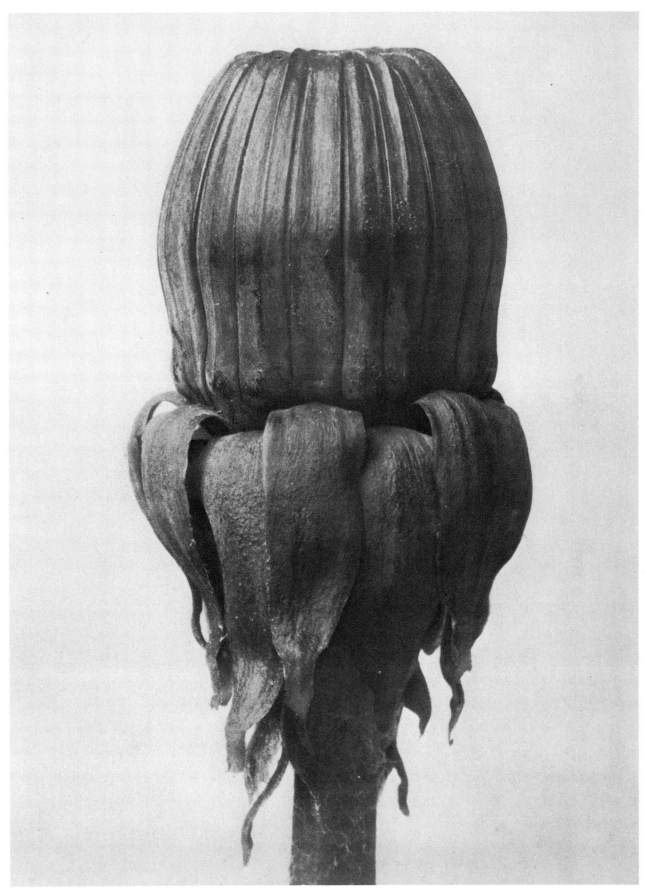

75. *Taraxacum officinale.* Common Dandelion, Blowballs. Flower bud enlarged 7.2 times.

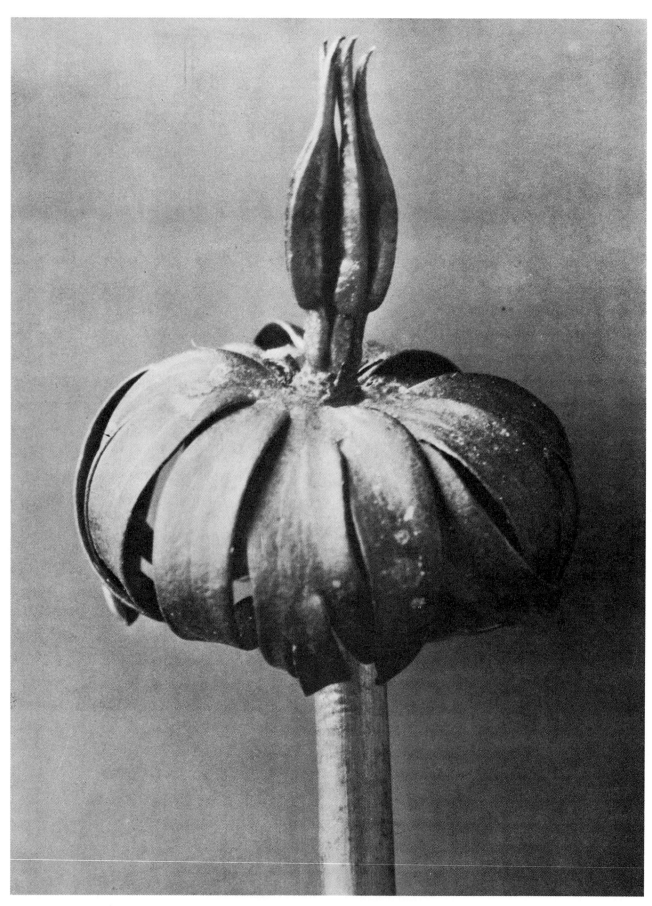

76. *Eranthis cilicicus*. Winter-Aconite, Hellebore. Fruit, with involucre, enlarged 7.2 times.

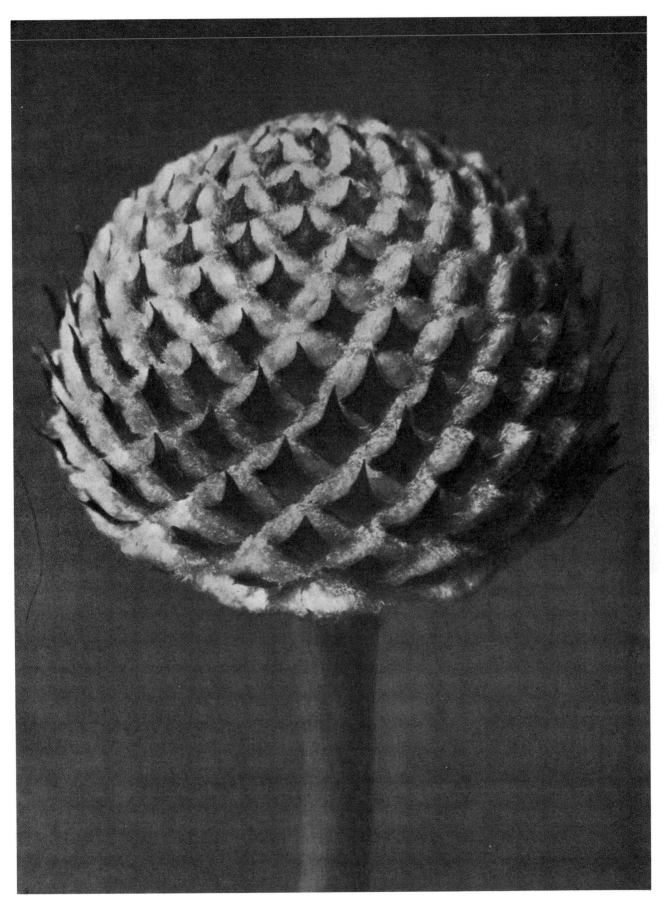

77. *Cephalaria*. Small Teasel. Glomerule enlarged 9.0 times.

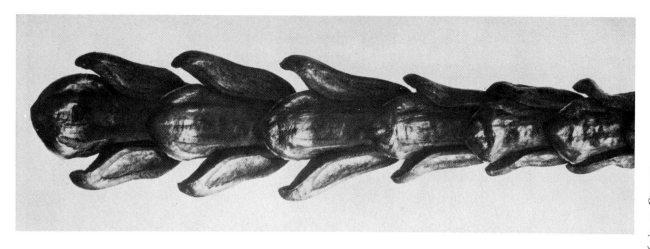

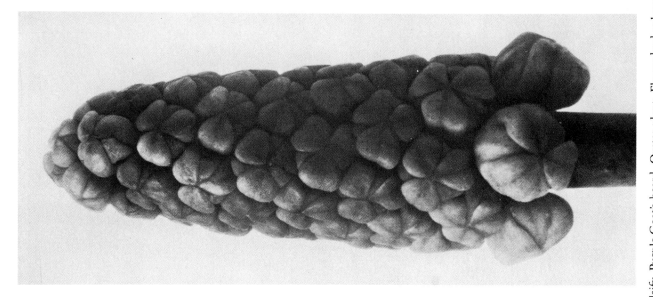

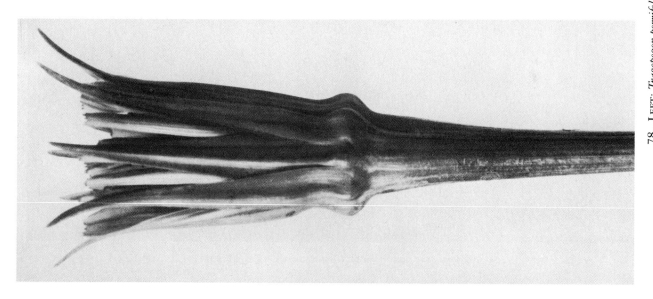

78. LEFT: *Tragopogon porrifolius*. Salsify, Purple Goat's-beard, Oyster-plant. Flower bud enlarged 3.6 times. CENTER: *Muscari racemosum*. Common Grape-Hyacinth. Raceme enlarged 10.8 times. RIGHT: *Thujopsis dolabrata*. Hiba Arbor Vitae, False Arbor Vitae. Part of branch enlarged 9.0 times.

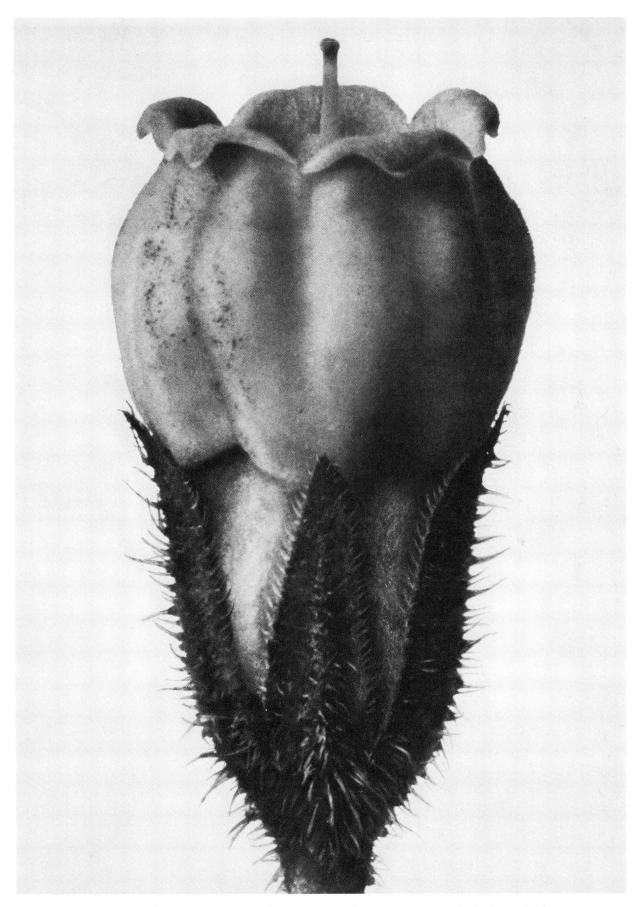

79. *Symphytum officinale.* Common Comfrey, Healing Herb, Boneset, Consound, Blackwort, Backwort. Flower enlarged 22.5 times.

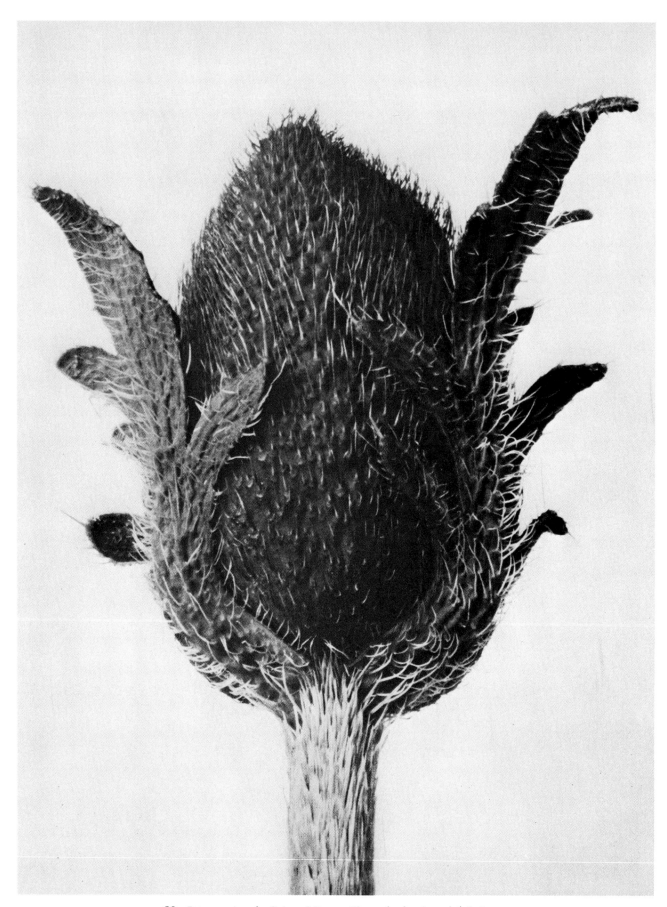

80. *Papaver orientale*. Oriental Poppy. Flower bud enlarged 4.5 times.

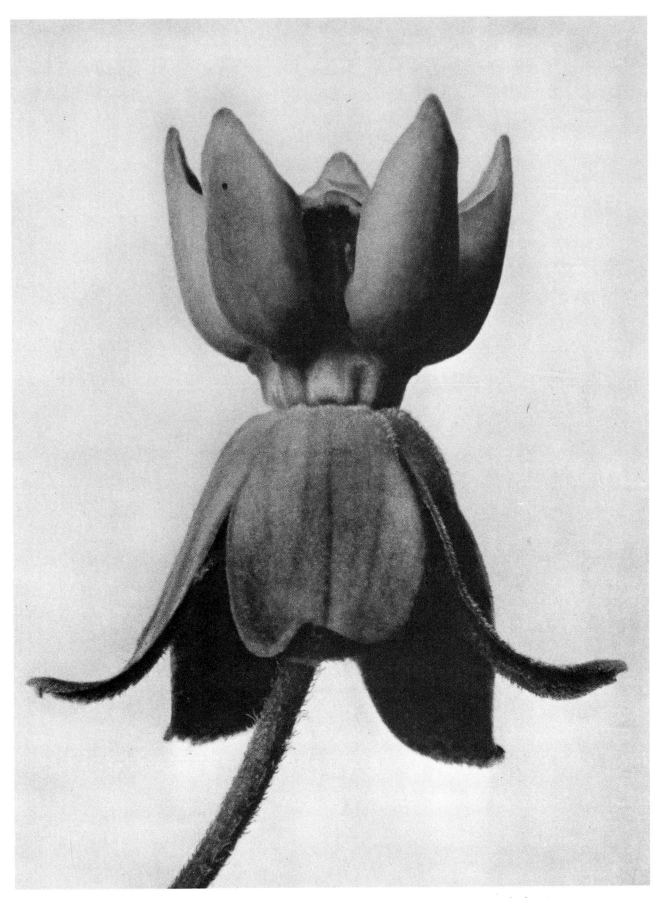

81. *Asclepias syriaca*. Common Milkweed or Silkweed, Swallowwort. Flower enlarged 16.2 times.

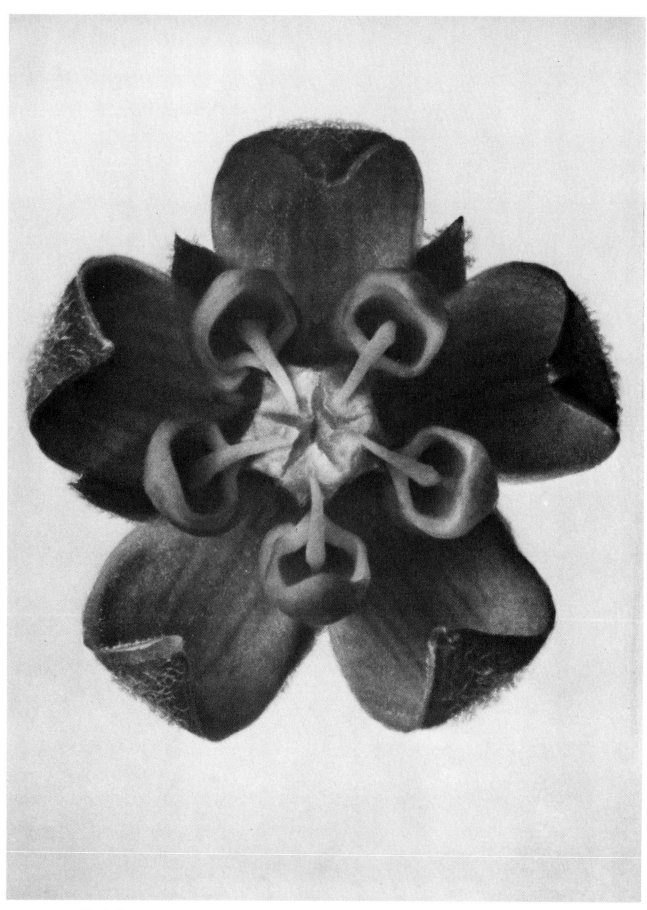

82. *Asclepias syriaca.* Common Milkweed or Silkweed, Swallowwort. Flower enlarged 16.2 times.

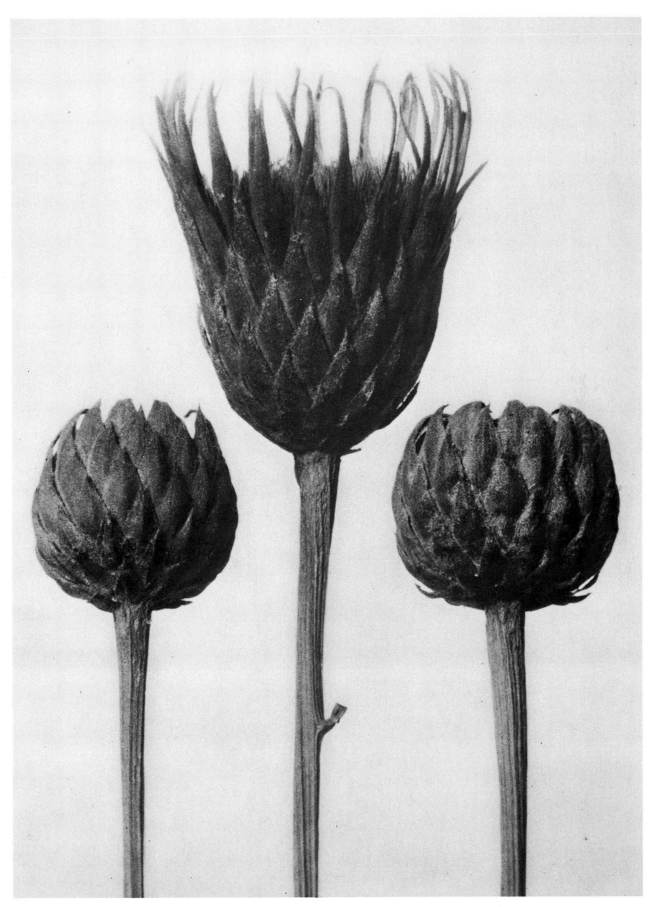

83. *Serratula nudicaulis*. Bare-stemmed Common Sawwort. Seedpods enlarged 4.5 times.

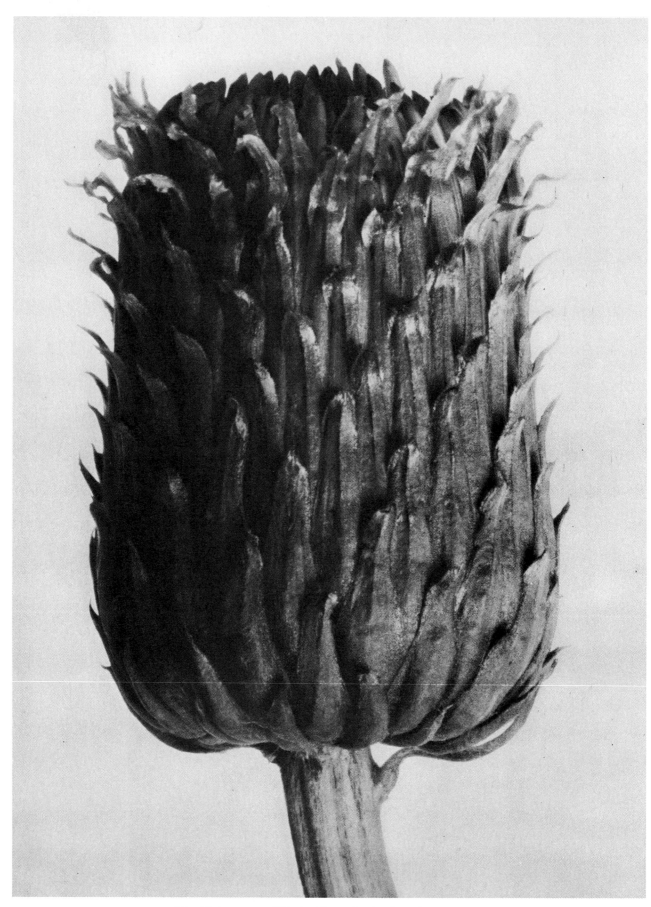

84. *Cirsium canum*. Thistle. Flower head enlarged 10.8 times.

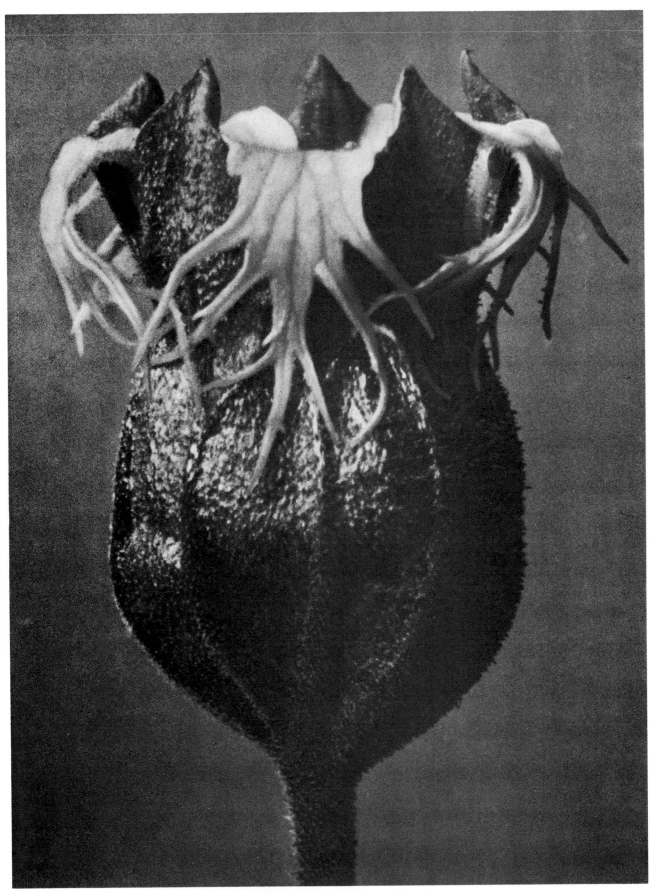

85. *Tellima grandiflora*. Fringecups. Flower enlarged 22.5 times.

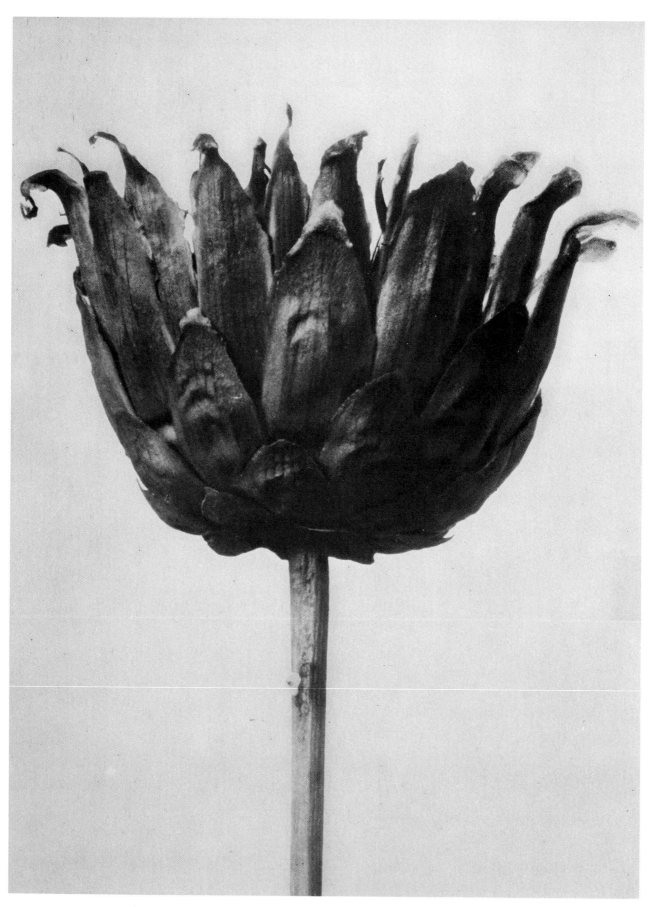

86. *Centaurea ruthenica*. Russian Knapweed. Seminal capsule enlarged 7.2 times.

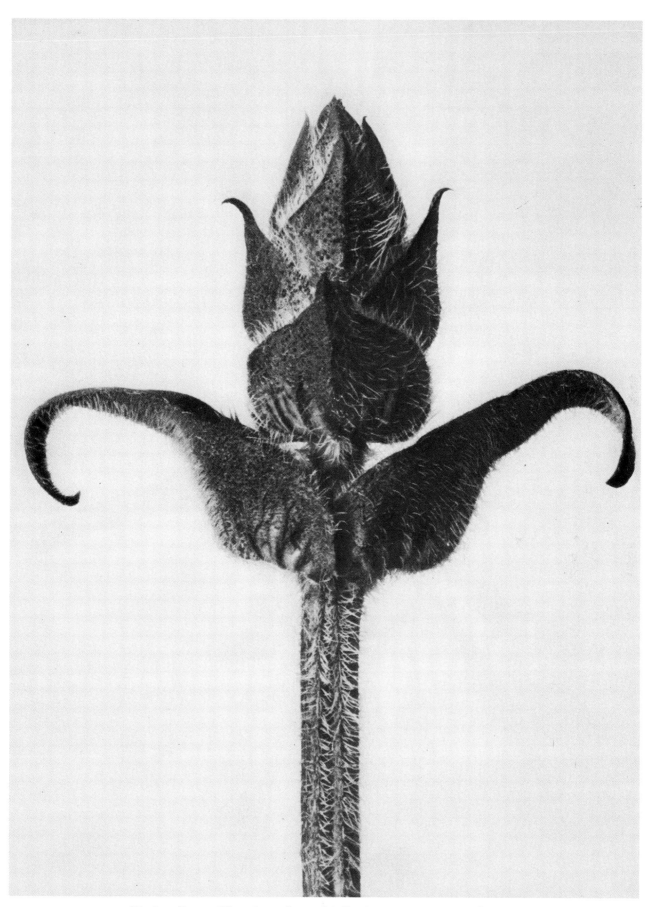

87. *Prunella grandiflora.* Large-flowered Selfheal. Young shoot enlarged 7.2 times.

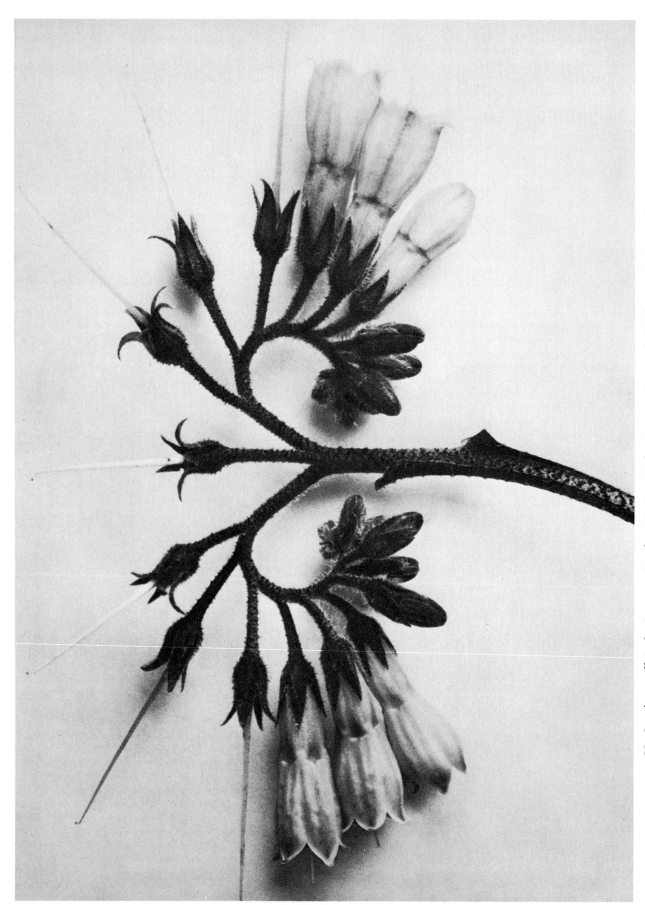

88. *Symphytum officinale.* Common Comfrey, Healing Herb, Boneset, Consound, Blackwort, Backwort. Cincinnus enlarged 7.2 times.

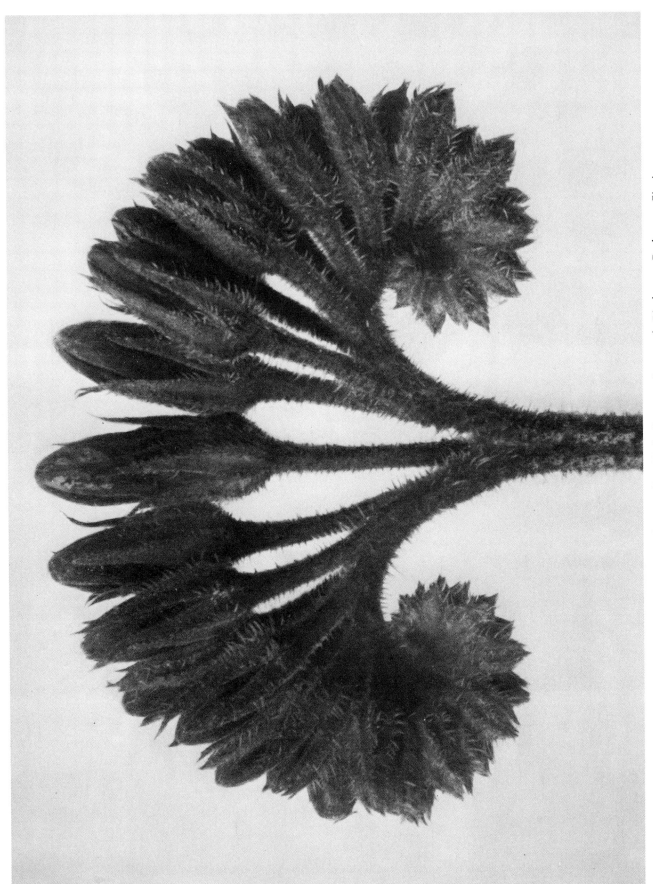

89. *Symphytum officinale*. Common Comfrey, Healing Herb, Boneset, Consound, Blackwort, Backwort. Cincinnus enlarged 7.2 times.

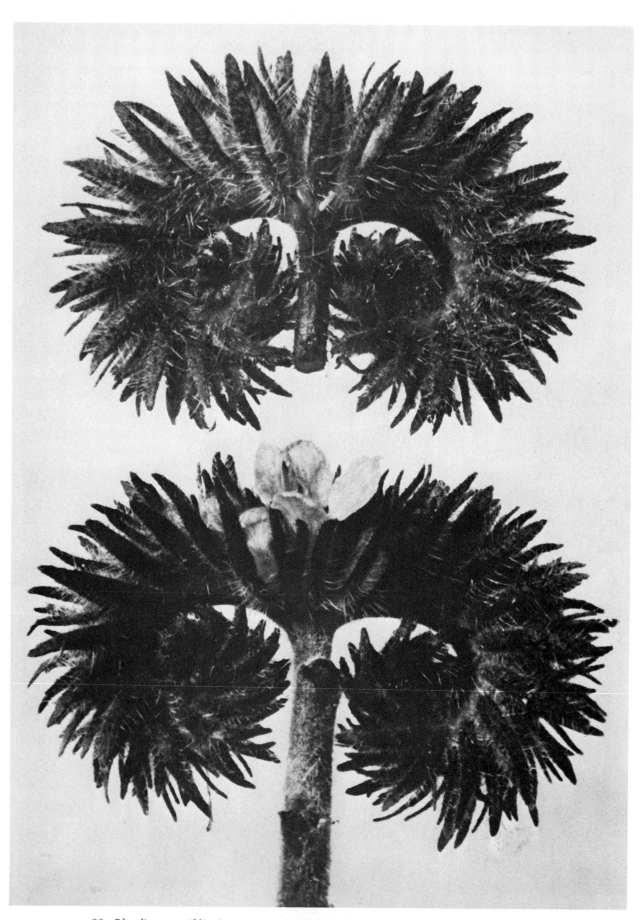

90. *Phacelia tanacetifolia*. Scorpion-weed, Fiddleneck Phacelia. Panicles enlarged 10.8 times.

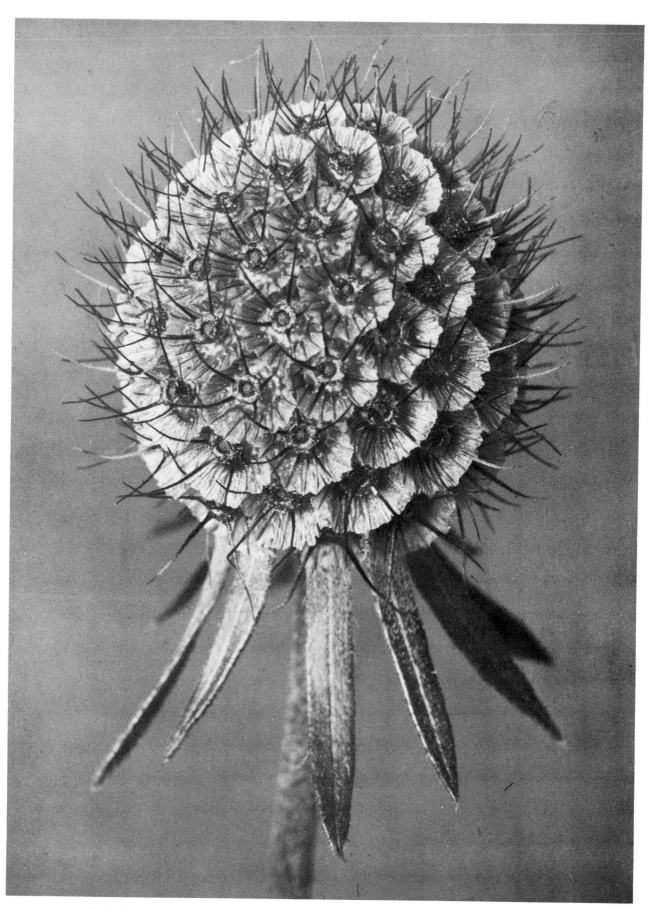

91. *Scabiosa columbaria*. Small or Lilac-flowered Scabious. Seminal capsule enlarged 9.0 times.

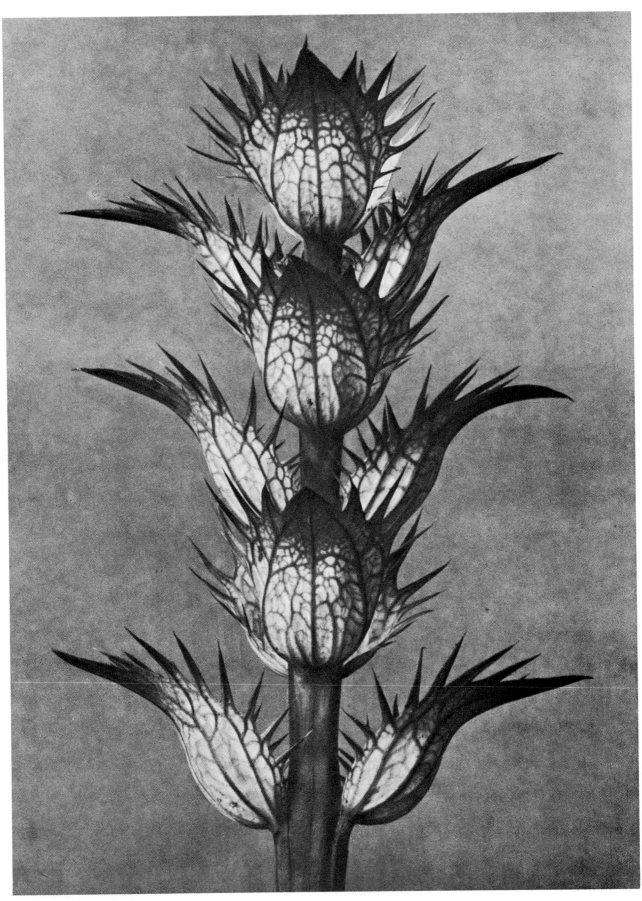

92. *Acanthus mollis*. Artist's, Common or Soft-leaved Bear's-Breech. Bracteoles, with the flowers removed, enlarged 3.6 times.

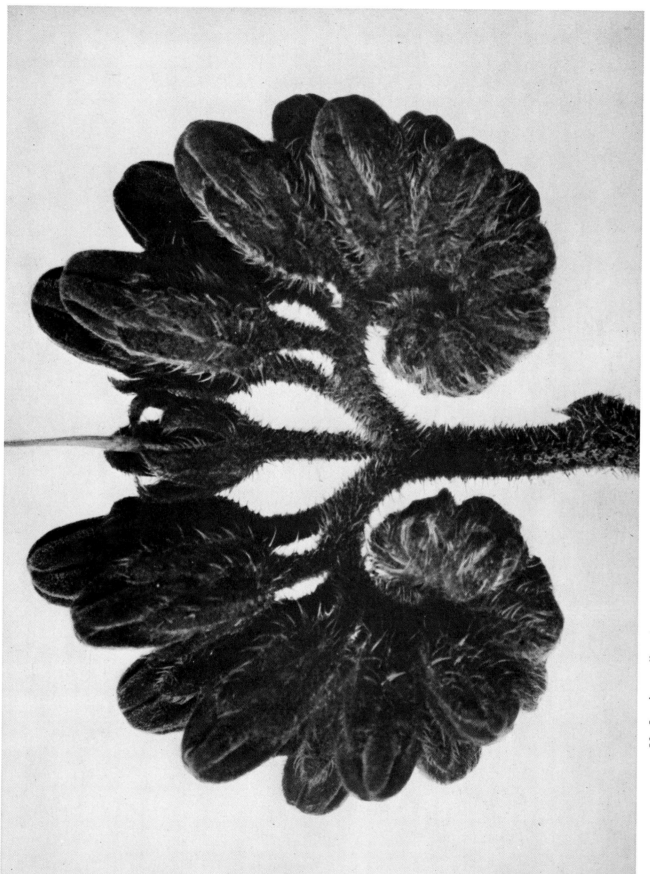

93. *Symphytum officinale.* Common Comfrey, Healing Herb, Boneset, Consound, Blackwort, Backwort. Inflorescence enlarged 7.2 times.

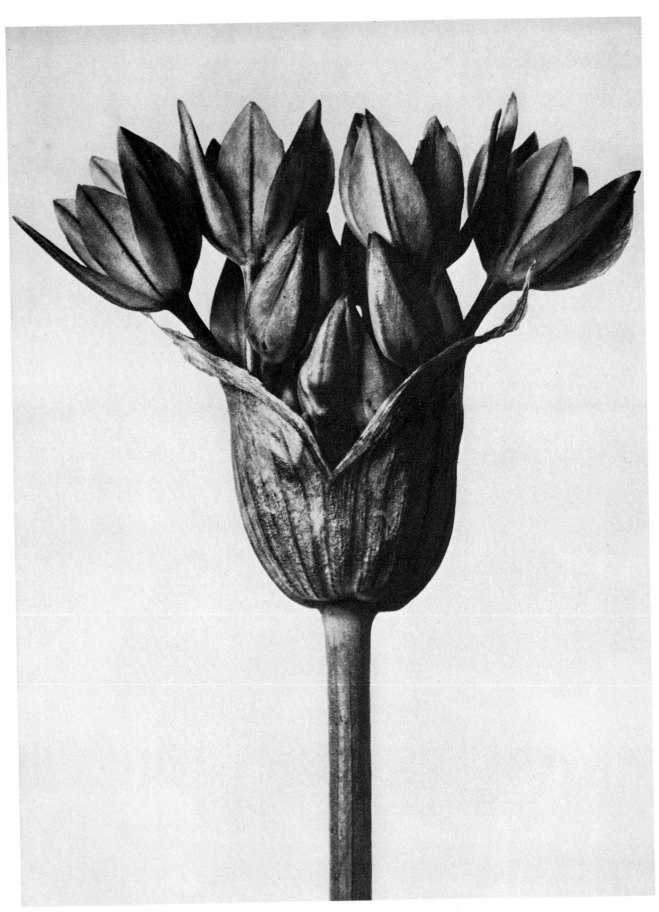

94. *Allium Ostrowskianum*. Garlic. Umbel enlarged 5.4 times.

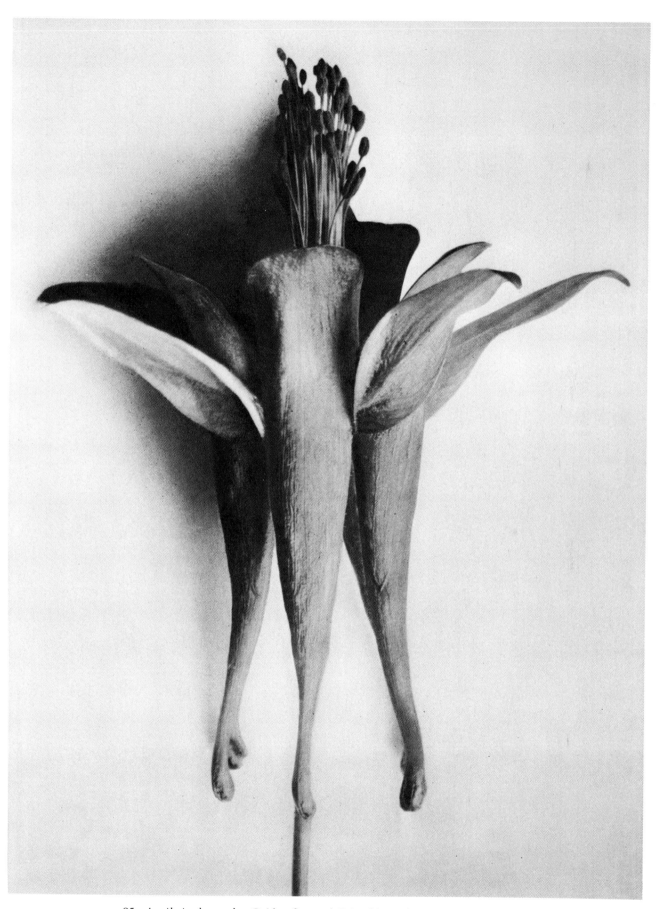

95. *Aquilegia chrysantha*. Golden-flowered Columbine. Flower enlarged 5.4 times.

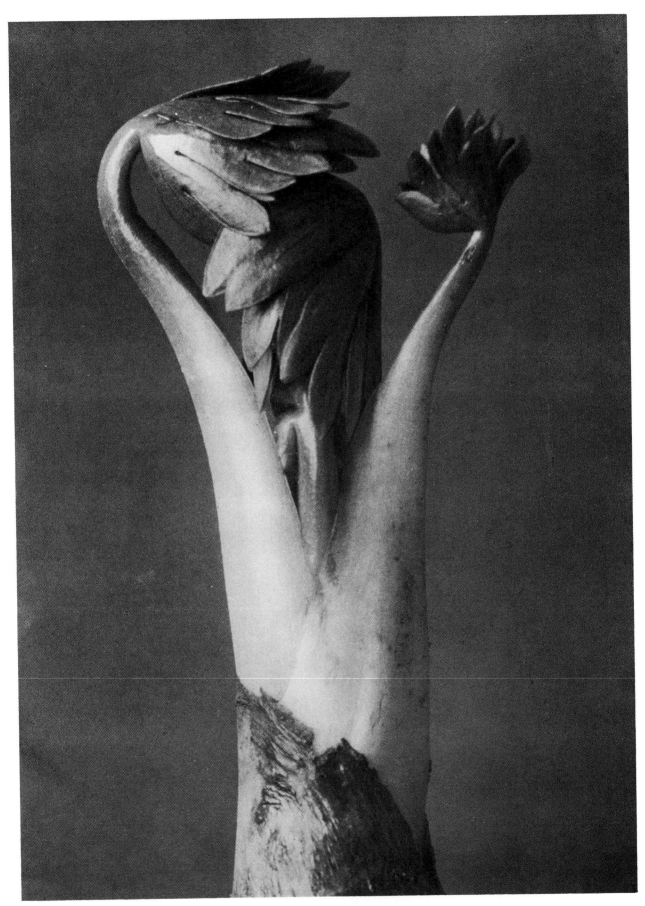

96. *Aconitum*. Aconite, Wolfsbane, Monkshood. Young shoot enlarged 5.4 times.

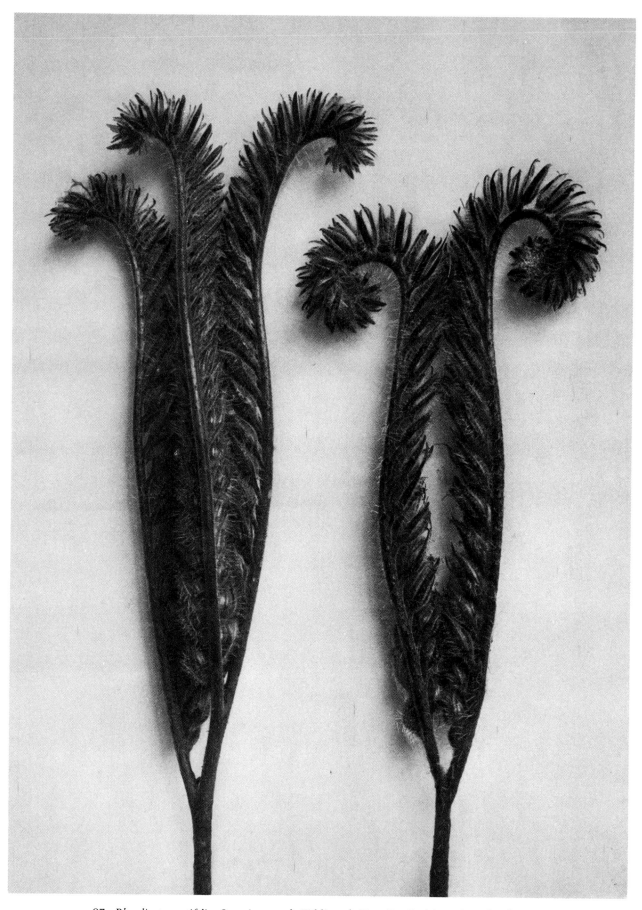

97. *Phacelia tanacetifolia*. Scorpion-weed, Fiddleneck Phacelia. Panicles enlarged 3.6 times.

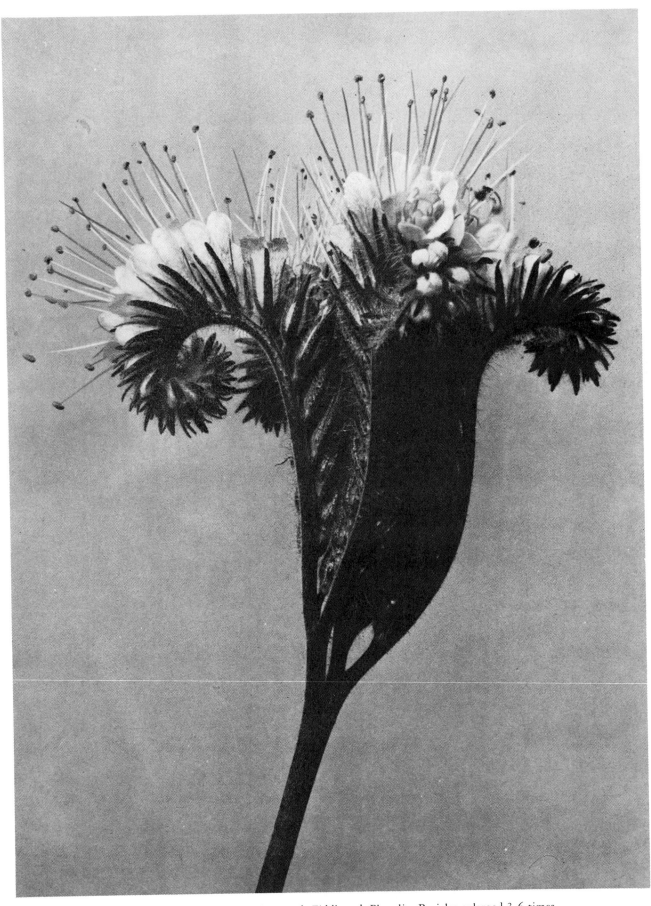

98. *Phacelia tanacetifolia*. Scorpion-weed, Fiddleneck Phacelia. Panicles enlarged 3.6 times.

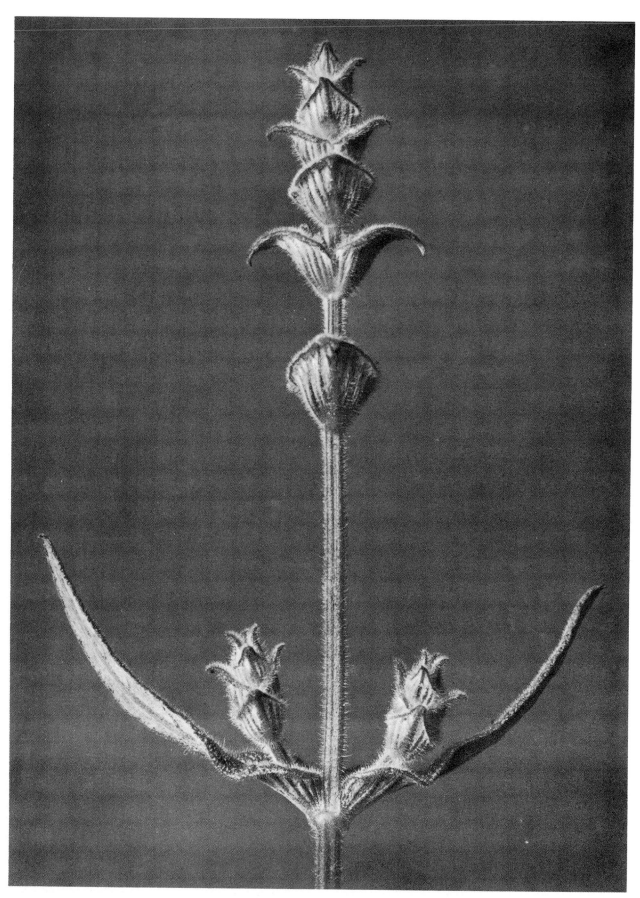

99. *Salvia.* Sage. Stem enlarged 4.5 times.

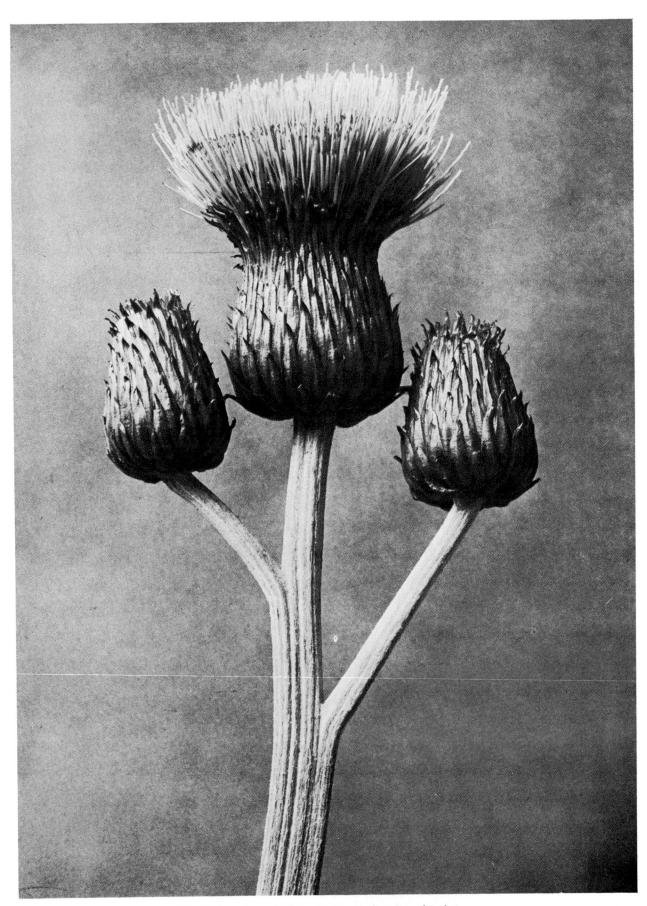

100. *Cirsium canum*. Thistle. Flower heads enlarged 3.6 times.

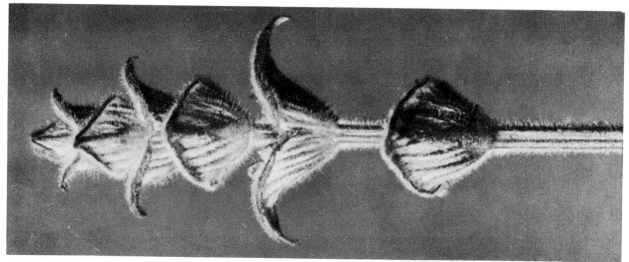

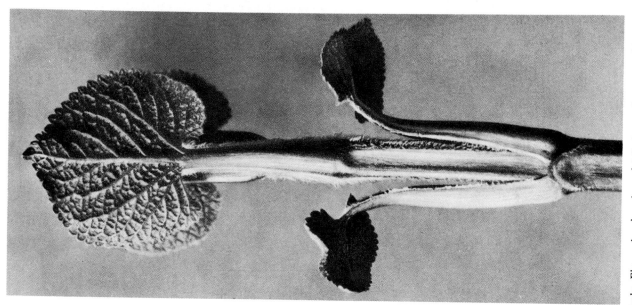

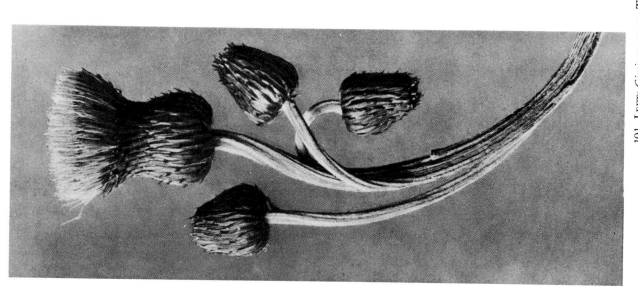

101. LEFT: *Cirsium canum*. Thistle. Flower heads enlarged 1.8 times. CENTER: *Phlomis umbrosa*. Shady Jerusalem Sage. Young shoot enlarged 3.6 times. RIGHT: *Salvia*. Sage. End of stem enlarged 5.4 times.

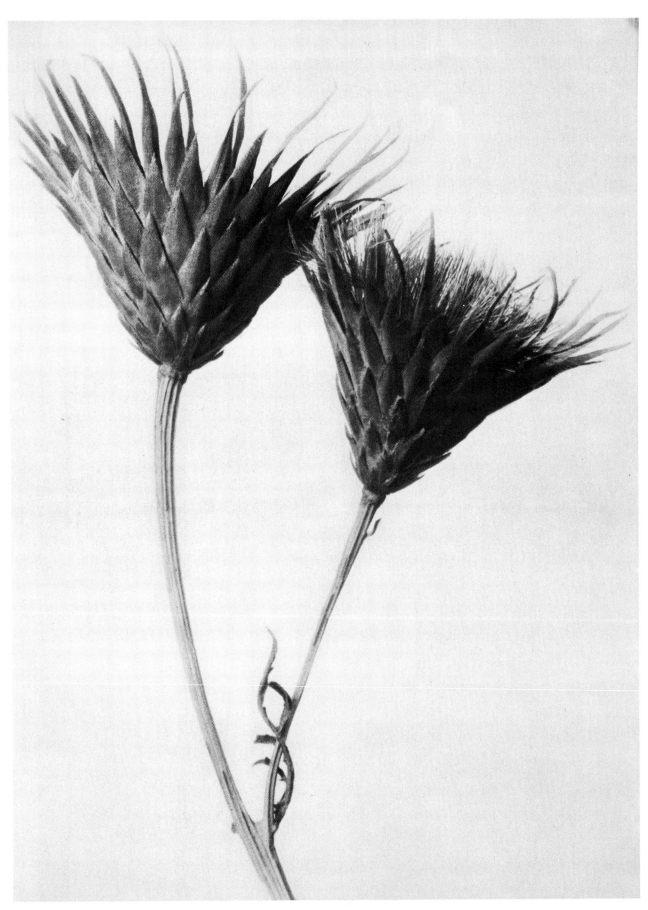

102. *Serratula nudicaulis*. Bare-stemmed Common Sawwort. Seedpods enlarged 3.6 times.

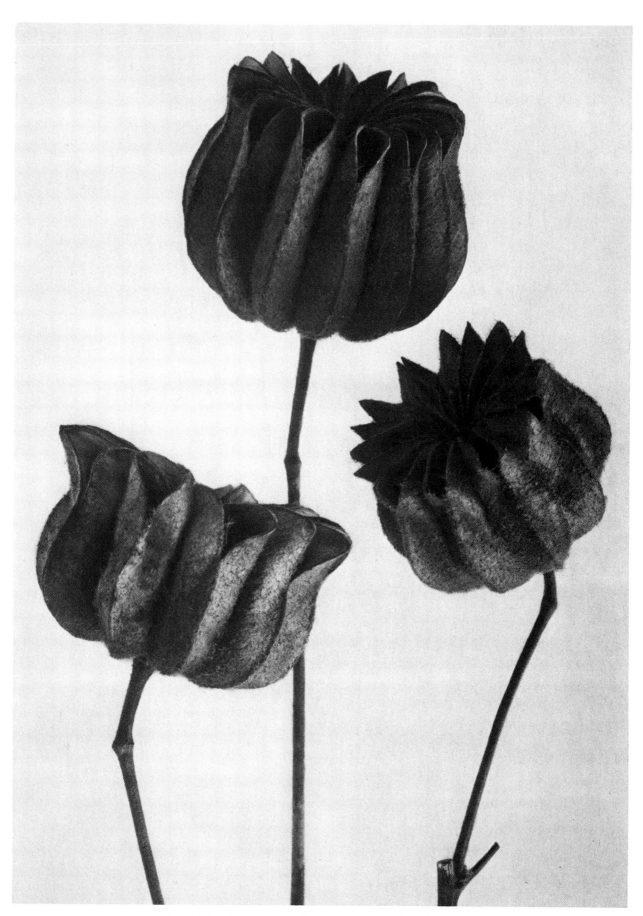

103. *Abutilon*. Lime Mallow. Seminal capsules enlarged 5.4 times.

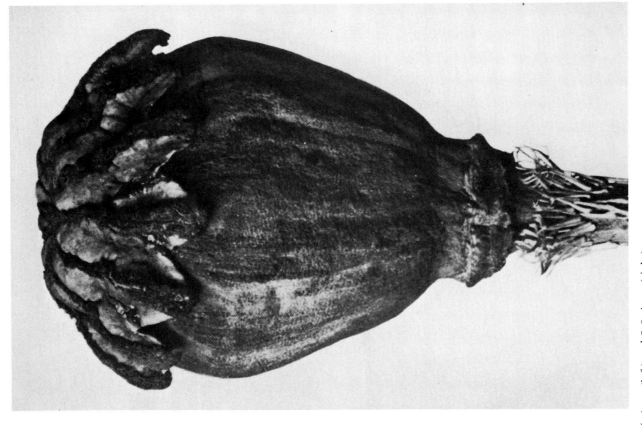

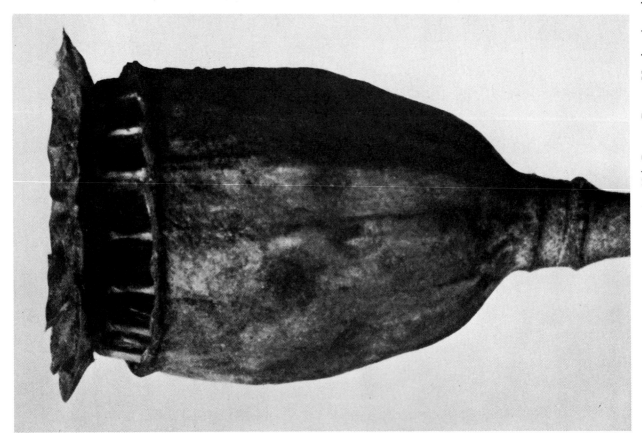

104. *Papaver.* Poppy. Heads enlarged 5.4 times (left) and 9.0 times (right).

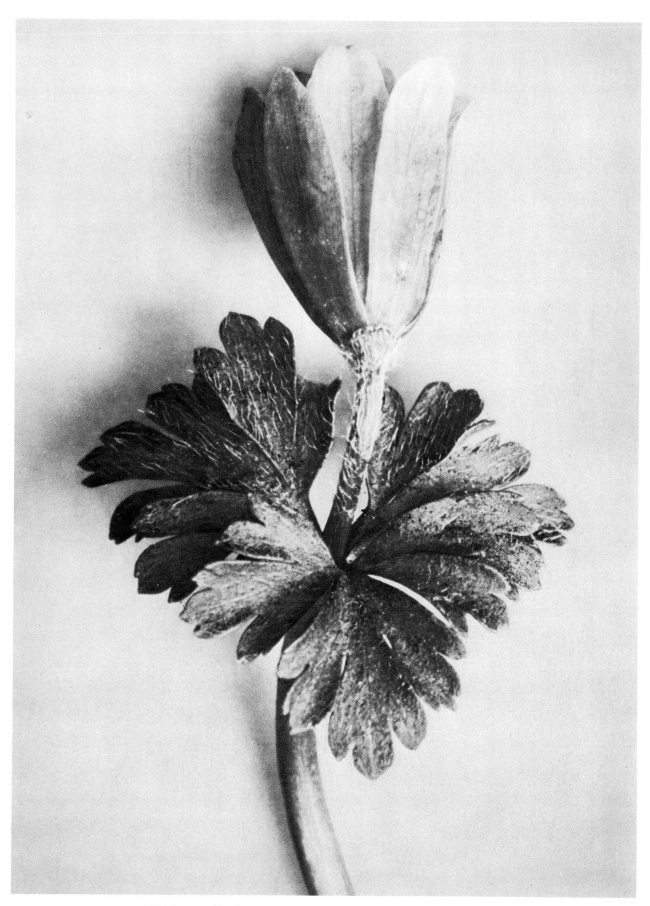

105. *Anemone blanda*. Anemone, Windflower. Flower enlarged 7.2 times.

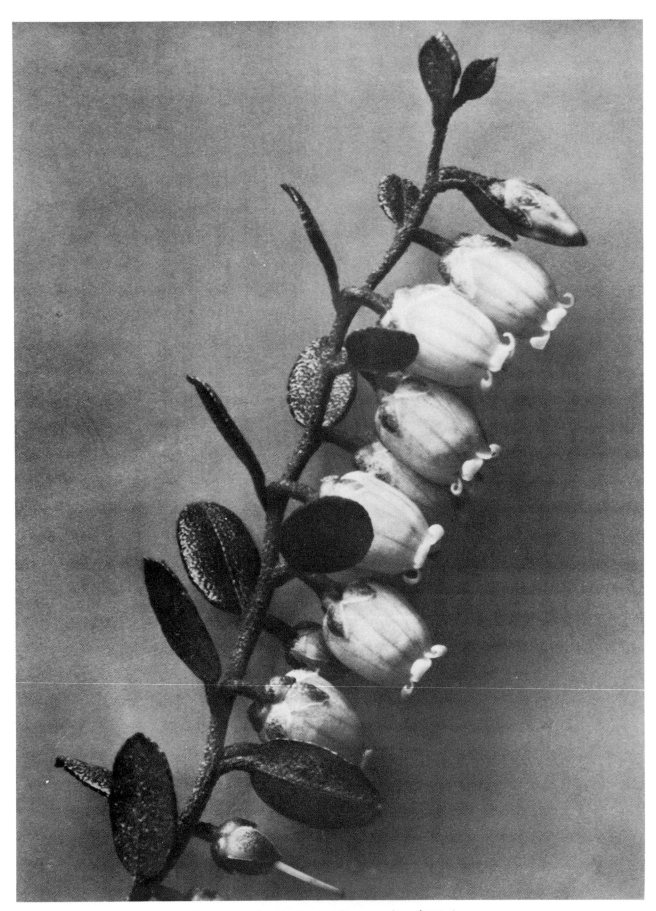

106. *Lyonia calyculata*. Lyonia. Flowers enlarged 7.2 times.

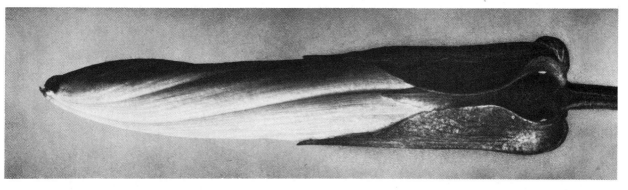

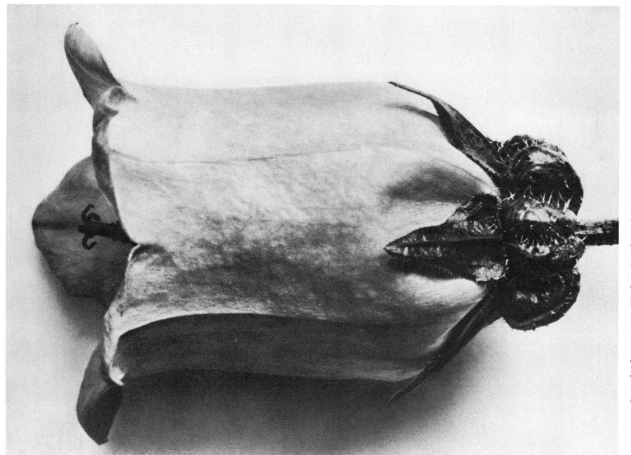

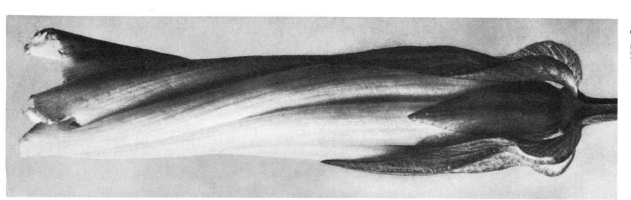

107. LEFT AND RIGHT: *Convolvulus sepium.* Hedge-Bindweed, Wild Morning-glory, Bell-bind, Wood-bind. Flower buds enlarged 4.5 times. CENTER: *Campanula Medium.* Canterbury-bells. Flower enlarged 5.4 times.

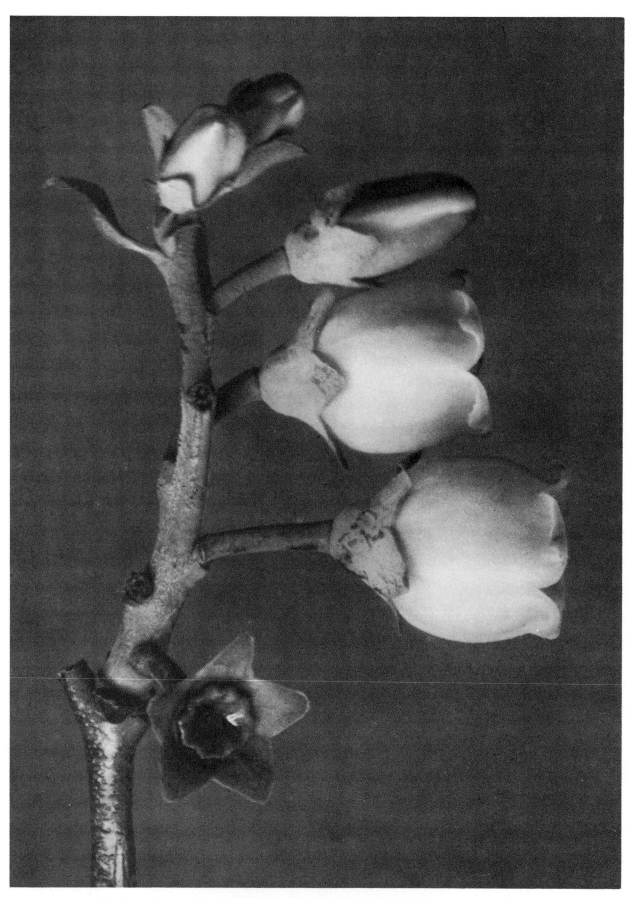

108. *Vaccinium corymbosum*. Highbush- or Swamp-Blueberry. Flowers enlarged 9.0 times.

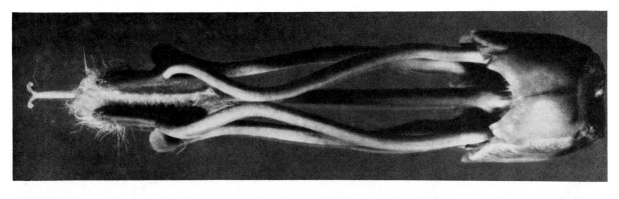

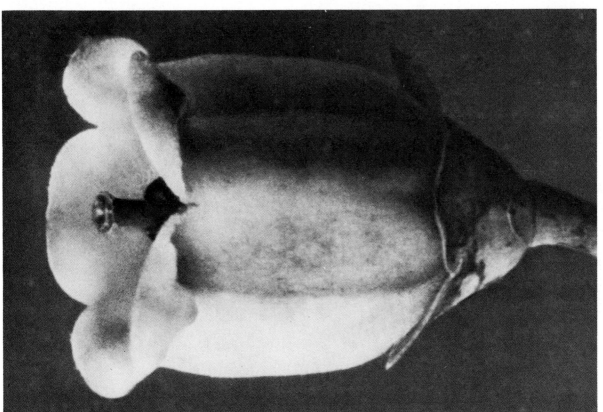

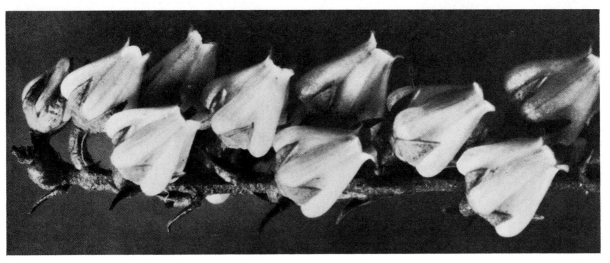

109. LEFT: *Andromeda floribunda.* Fetterbush, Free-flowering Andromeda. Flowers enlarged 5.4 times. CENTER: *Vaccinium corymbosum.* Highbush- or Swamp-Blueberry. Flower enlarged 18.0 times. RIGHT: *Acanthus mollis.* Artist's, Common or Soft-leaved Bear's Breech. Inner parts of flower enlarged 4.5 times.

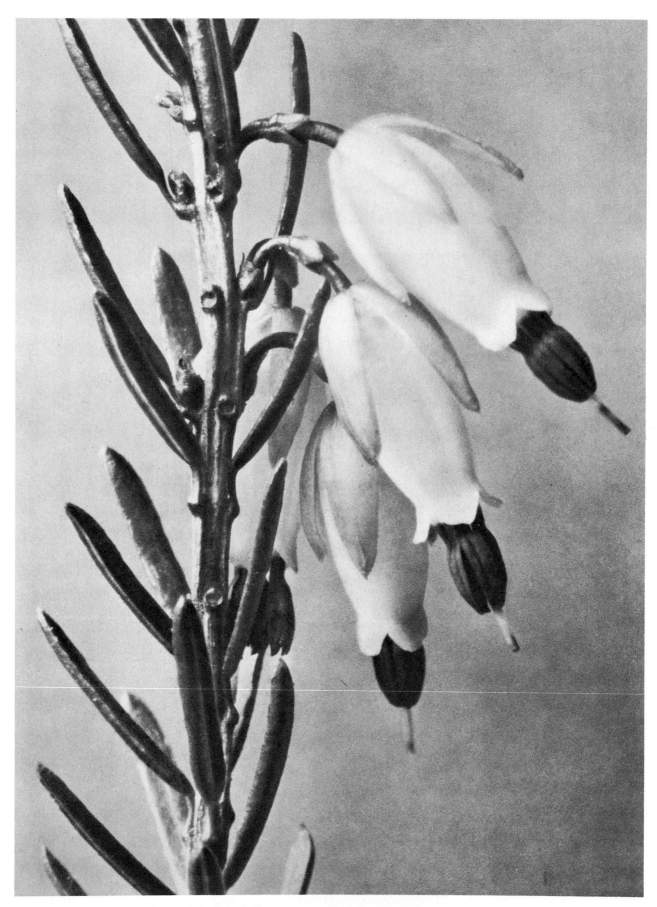

110. *Erica herbacea*. Heath. Flowers enlarged 14.4 times.

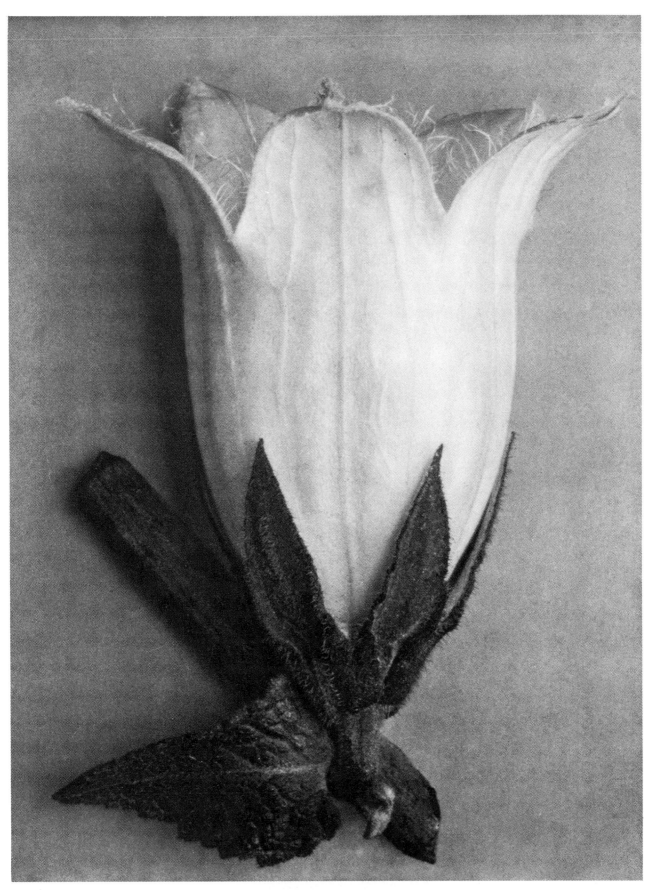

111. *Campanula alliariifolia*. Bellflower. Flower enlarged 9.0 times.

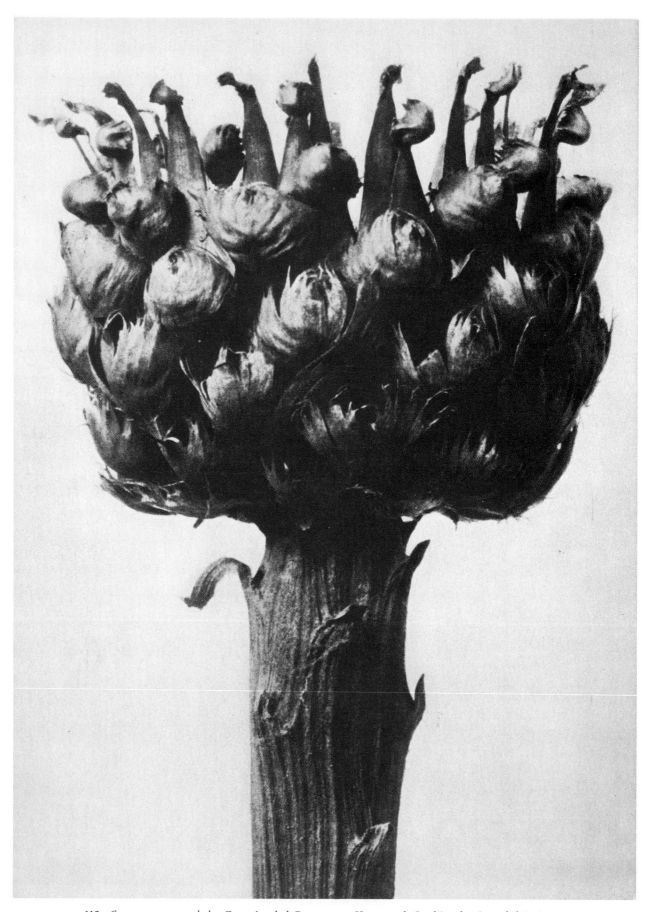

112. *Centaurea macrocephala*. Great-headed Centaury or Knapweed. Seed head enlarged 4.5 times.

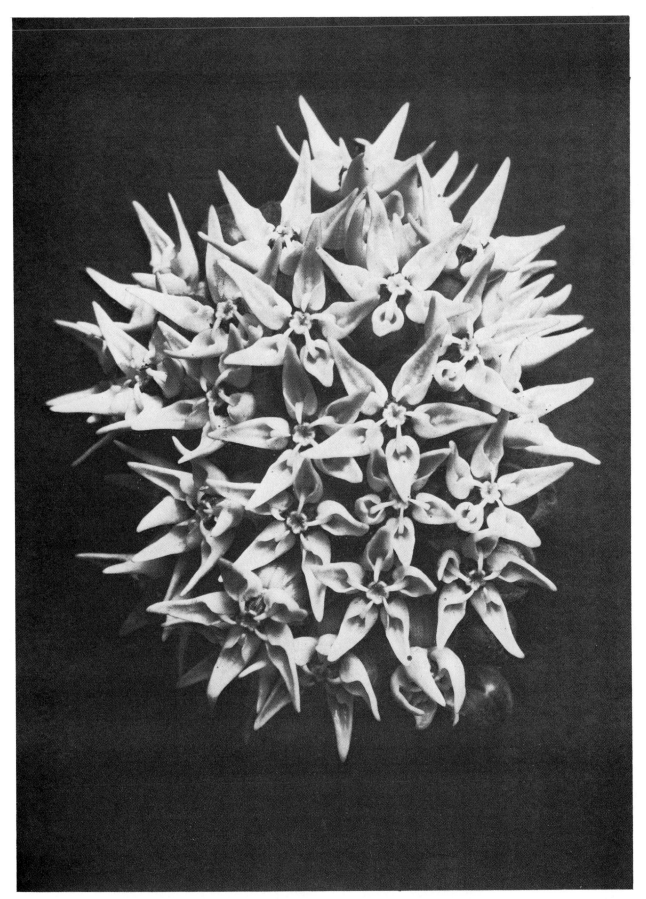

113. *Asclepias speciosa*. Showy Milkweed. Umbel enlarged 2.7 times.

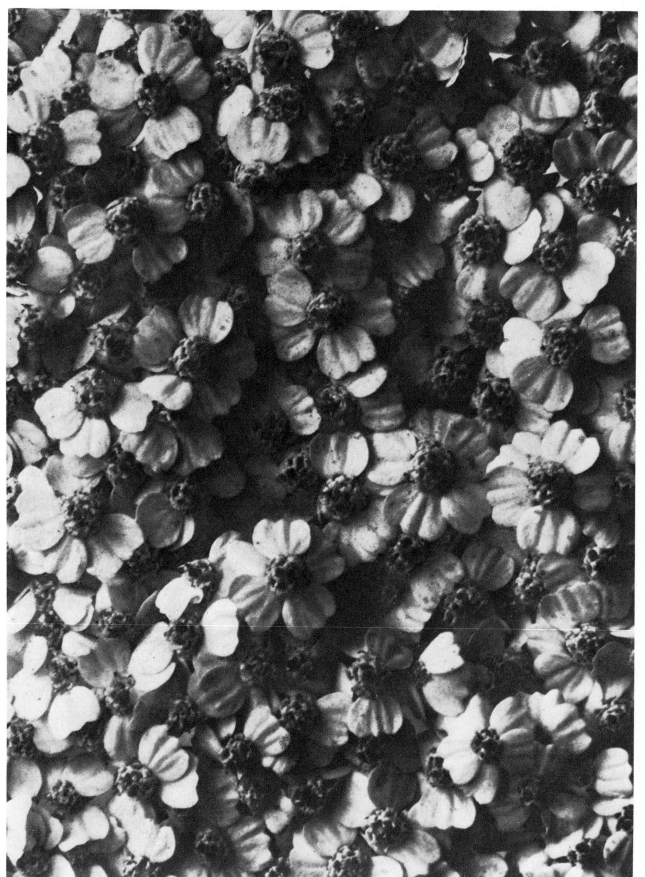

114. *Achillea Millefolium.* Common Milfoil or Yarrow, Sanguinary, Thousand-seal, Nosebleed. Cyme enlarged 7.2 times.

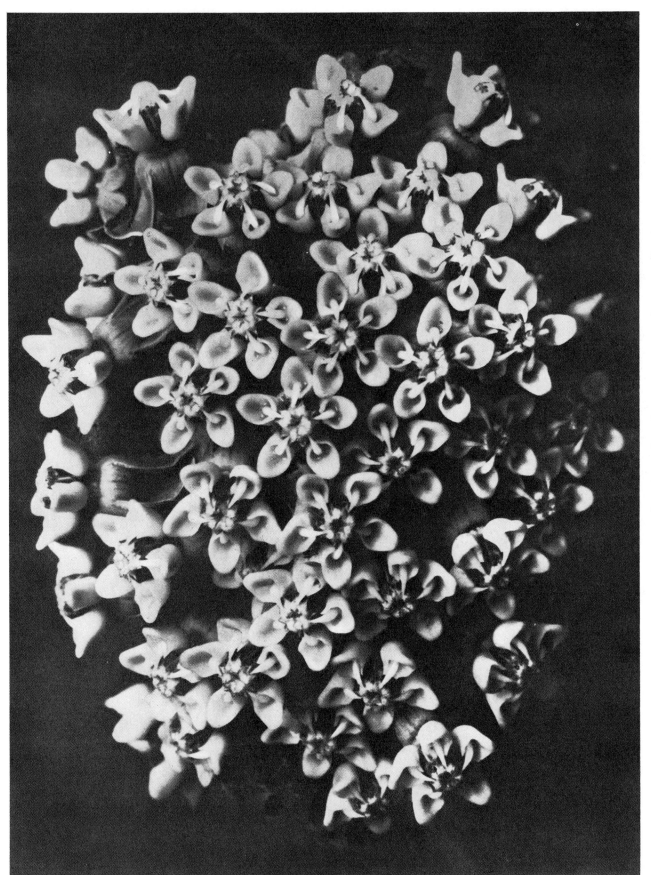

115. *Asclepias syriaca.* Common Milkweed or Silkweed, Swallowwort. Umbel enlarged 5.4 times.

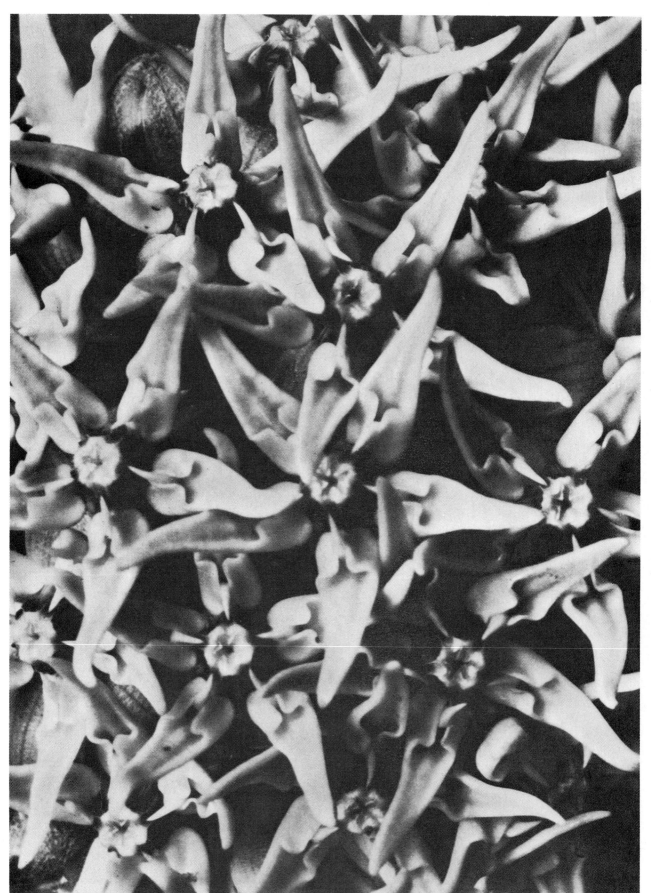

116. *Asclepias speciosa*. Showy Milkweed. Umbel enlarged 7.2 times.

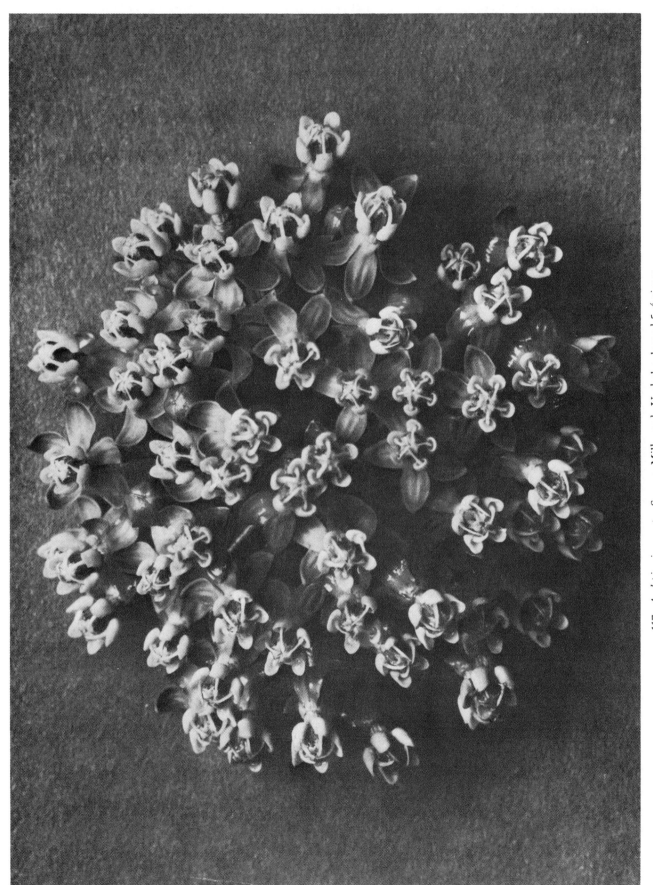

117. *Asclepias incarnata.* Swamp Milkweed. Umbel enlarged 5.4 times.

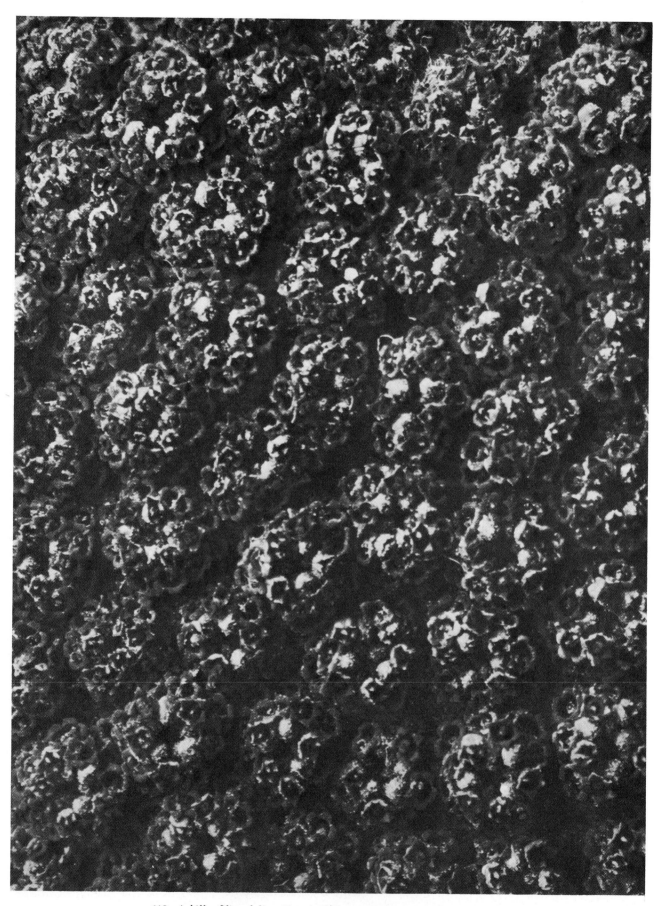

118. *Achillea filipendulina*. Fern-leaf Yarrow. Cyme enlarged 13.5 times.

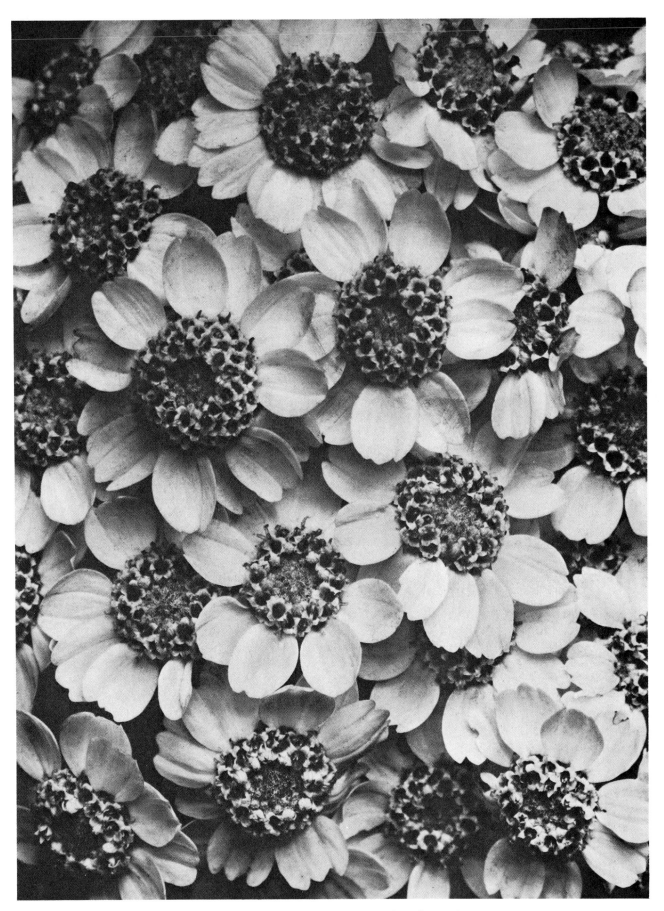

119. *Achillea clypeolata*. Yarrow. Cyme enlarged 13.5 times.

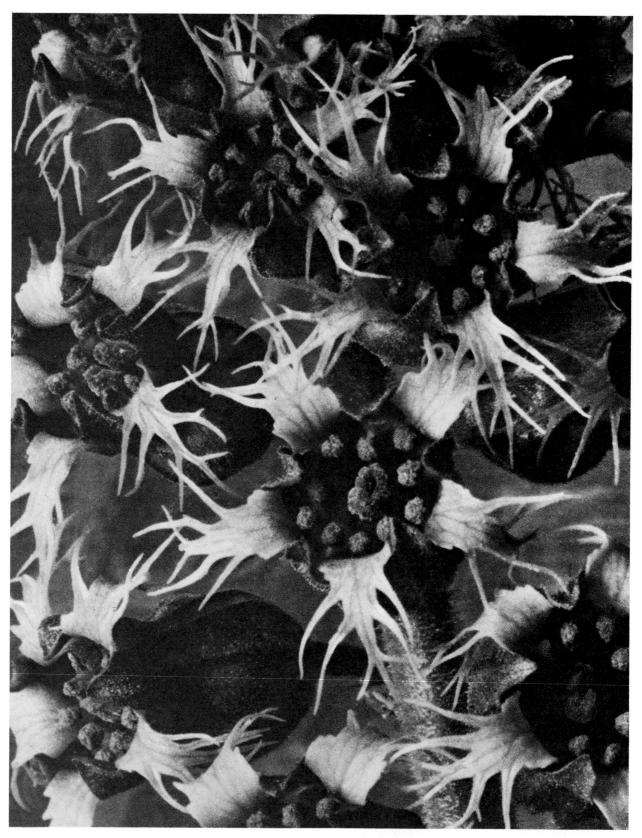

120. *Tellima grandiflora*. Fringecups. Flower enlarged 10.8 times.